Rarities of the Musée Guimet

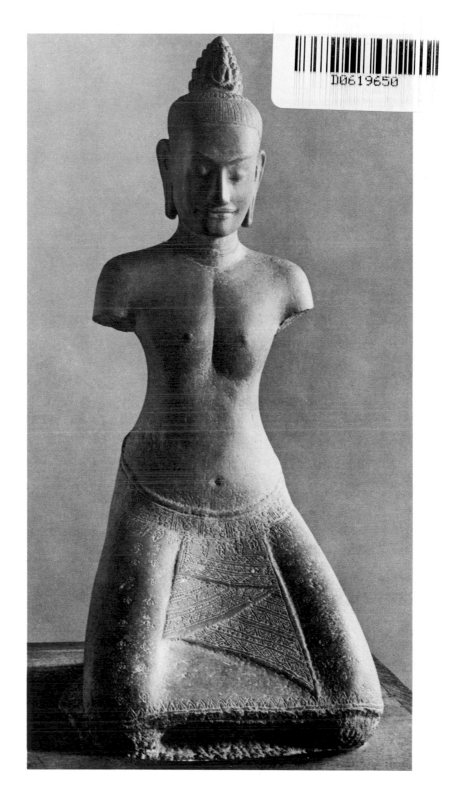

The Asia Society gratefully acknowledges the invaluable contributions of many organizations and individuals to the Guimet exhibition. Many friends in France have given generously of their aid and helpful counsel throughout this entire project. They are: Mme. Roger Dernis, M. Olivier Lefuel, M. Francois Monahan, M. Robert Montarnal, Mme. Philibert Ravier and Mme. Charles Roussignhol.

We also wish to thank M. Jean Chenue of André Chenue et Cie. and M. Jacques Gaillard and M. Robert de Padova of Air France.

The New York State Council on the Arts, Air France, and Cointreau Ltd. have each recently provided generous grants towards this project.

The sculpture described and illustrated has been substituted for catalogue No. 19, *Harihara*.

25 *a* KNEELING FEMALE FIGURE MG 18043
 Cambodia; Khmer, late twelfth–early thirteenth century
 Sandstone; H. 43¼ *in.* (110 *cm.*)

This figure, one of the most beautiful Buddhist images produced during the reign of Jayavarman VII (ca. 1181–1218; see No. 25), may be a posthumous portrait of Queen Jayarājadevī, his first wife, here deified as the goddess Tārā (the Savior) or perhaps as Prajñāpāramitā (the Perfection of Wisdom). Her eyes are closed, her head is lowered, and she smiles faintly, as if engaged in meditation. A haloed image of the Esoteric Buddhist Jina Amitābha has been placed at the front of her conical chignon. The accentuation of the groove between her small breasts indicates that her arms were once extended in front of her, in a gesture of offering or prayer. There are "beauty folds" around her neck. Held in place by a jeweled belt hung with pendants, her skirt is ornamented with a pattern of small flowers and the flap of the fabric is folded so that it falls in decorative zig-zag folds. Modeled with supreme skill and assurance, the image conveys both the spirituality and the realism that are characteristic of the Bayon style. The head has been reattached to the figure. Both the feet and the circular base were roughly carved. Coedès, in the article cited below, mentions three other kneeling figures, one of which was found near a statue thought to represent Jayavarman VII, that may also depict the Queen.

From Preah Khan, Angkor, from the finds of the EFEO expedition, 1929. Sent to the Musée Guimet in 1931.

Published: BEFEO, vol. XXIX (1929), p. 515; BEFEO, vol. XXX (1930), p. 225; BEFEO, vol. XXXI (1931), pp. 641, 645; P. Dupont, *Musée Guimet: Catalogue des collections indochinoises* (Paris, 1934), p. 125; J. Boisselier, *La Statuaire khmère et son évolution* (Saigon: EFEO, 1955), pl. 77b, p. 188; G. Coedès, "Le Portrait dans l'art khmer," *Arts Asiatiques*, vol. VIII, no. 3 (1960), pp. 179–98, illus. fig. 11, p. 195; O. Monod, *Le Musée Guimet* (Paris, 1966), fig. 78, p. 161; *Gime Tōyō Bijutsukan* (Tokyo: Kodansha, 1968), pl. 24.

Rarities of the Musée Guimet

Asia House Gallery, New York City

Nelson–Atkins Gallery of Art, Kansas City, Missouri

Asian Art Museum of San Francisco: The Avery Brundage Collection
San Francisco, California

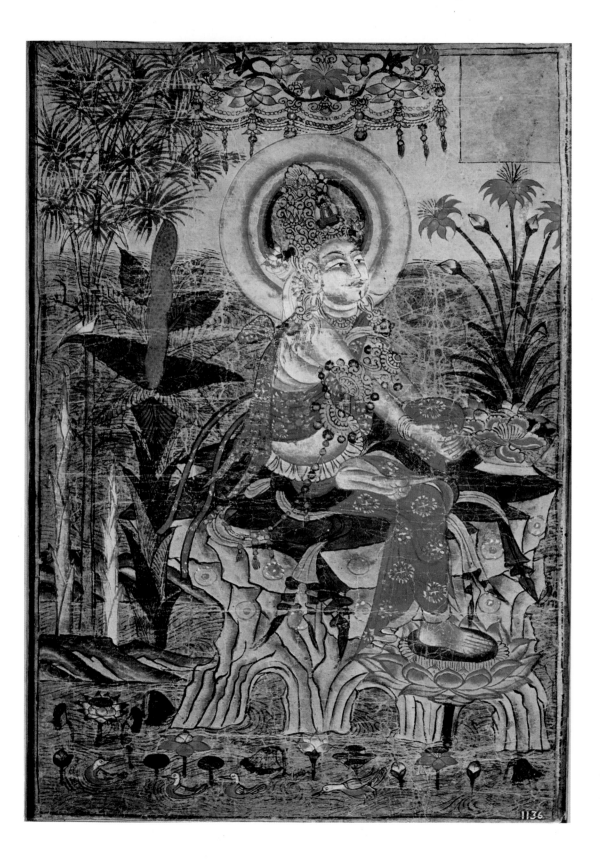

Rarities of the Musée Guimet

Introduction by Jeannine Auboyer

The Asia Society, Inc.

DISTRIBUTED BY NEW YORK GRAPHIC SOCIETY LTD.

Frontispiece: No. 45. *Chou-yue Kuan-yin*.
Tun-huang; late ninth–early tenth century.
Painting on paper; H. 20⅞ in.

RARITIES OF THE MUSÉE GUIMET is the catalogue of an
exhibition shown in the Asia House Gallery in 1975 as an activity of
The Asia Society.

An Asia House Gallery Publication

Library of Congress Catalogue Card Number: 74-81967
SBN: 0-87848-043-9
Printed in Japan.

This project is supported by a grant from the National Endowment
for the Arts, Washington, D.C., a Federal Agency.

The publication of this volume has been made possible through
the generosity of The Friends of Asia House Gallery.

Contents

Foreword

SINCE its opening in 1960, the Asia House Gallery of The Asia Society has presented forty-eight exhibitions of wide variety and high quality. As we look back at the content of these displays, it seems a difficult challenge to mount an exhibition which could be completely original as well as being the sort of offering many have come to expect of the Gallery. The coming together of the Musée Guimet and Asia House Gallery is truly a notable event. It represents the first time we have been able to bring a survey of Oriental art from a single European museum to this country, and, indeed, the first time in its long existence that the Guimet itself has agreed to an undertaking of this nature. We might even dare hope that such good fortune and generosity will set a precedent for similar ventures in the future.

From both standpoints of quality and depth, the Guimet is undeniably one of the great Oriental collections of the world. This preeminence has long been recognized by scholars, as Chief Curator Jeannine Auboyer notes in her fascinating history of the museum. I would suspect, however, that it has only recently become better known to the public. Undoubtedly the current deepening of interest in the Far East, as well as the ongoing completion of a long-range expansion and reinstallation program carried out by the museum, has contributed to this situation. Thus, our ability to show a survey of the collections in America is especially timely, and will certainly bring about many future visits to the museum in Paris by those who wish to see the great pieces which could not travel.

The difficult and pleasant task of selection was skillfully carried out by Mlle. Auboyer and Laurence Sickman, who is Director of the Nelson-Atkins Gallery of Art in Kansas City, Missouri, and its distinguished curator-emeritus of Oriental art. They were faced with the well-known restrictions of being unable to send objects of great size or extreme fragility, but given the great depths of the collection, it was not difficult to assemble an exhibition which amply represents its quality. In addition, Mlle. Auboyer and Mr. Sickman decided not to show objects in various categories that were already well represented in America and had been given good exposure in our galleries. This accounts for the absence of Chinese paintings and porcelains of all kinds in the display.

The remarkable pre-Khmer and Khmer stone objects, certainly the best group outside of Indochina itself, the depth of the Indian sculpture collections, the unique paintings of the eighth to tenth century from Tun-huang, the stuccos of Hadda, and even fragments from the frescoes at Douldour-âqour are all represented here in generous numbers.

Because my appointment was made after most of the negotiations had been completed, I have asked Lionel Landry to tell something of the background of the exhibition, and the many people who helped bring it to us. I add my thanks to his. As to Mr. Landry himself, it is certainly accurate to say that this project never would have come into being without his interest and enthusiasm. It was he who first brought the idea to the attention of the French officials and he has patiently followed it through all its vicissitudes since. To work with him on such a fine exhibition has been a privilege.

Allen Wardwell
Director, Asia House Gallery

Acknowledgments

ASIAN STUDIES seek to do more than to unlock the ancient mysteries of the Oriental past. They seek to reveal to man something more of man.

Such work has always enjoyed a benign climate in France with its great traditions of humanism, a humanism that finds in man, no matter how far removed in space, time and culture, a bond of common quest and aspiration.

For all the superficial and decorative chinoiserie of the age of Versailles, with its ormolu-mounted porcelains and Pillement mandarins, there were already afoot in the Orient solid, even heroic, French investigations of Asia, Asian life, and Asian art. The seventeenth century had seen, for instance, the prescient linguistic analyses of the French Jesuits in Viet Nam. Later, from Rangoon, Bishop Bigandet's *The Life or the Legend of Gautama* was probably the first sympathetic philosophical account of Theravada Buddhism to reach Europe.

In the present century, the efforts, lonely and often discouraging but in the end worth every travail, of a Duroiselle in Burma, a Damais in Java, the Grosliers, *père et fils*, in Cambodia, to name but very few, carried forward the great French contribution, too little known here, to our storehouse of knowledge about Asia. Of these, and of all those who formed the continuity of those French investigations across four centuries, this exhibition is as much a celebration as it is an act of homage to the great museum—the Musée Guimet—which, with the Ecole Française d'Extrême-Orient, keeps their accomplishments alive.

The Musée Guimet has been a good friend of the Asia Society for many years. With never-failing courtesy and a gratifying spirit of cooperation, it has lent to our Asia House Gallery exhibitions a succession of masterpieces of Oriental art.

It was perhaps inevitable that, one day, the Asia House Gallery should, in acknowledgment of a debt and a spirit of homage, dedicate a special exhibition entirely to the collections of this great museum, not only one of the world's major repositories of the arts of Asia but also the living symbol of the fine French tradition of scholarly investigation of Asia's patrimony. Miss Jeannine Auboyer, Conservateur-en-chef of the Musée Guimet, has offered never-failing courtesy, cooperation, and invaluable help from the inception of the project. Our obligation to her is incalculable. Mention must also be made here of the cheerful help we received at the museum from curator Gilles Béguin, who assisted in many details.

From American sources, contributions to the Society have given substantial assistance in funding this tribute. The National Endowment for the Arts, Washington, D.C., has been particularly helpful. The Friends of Asia House Gallery have contributed the cost of publishing the exhibition's catalogue and the Society gratefully acknowledges its debt to them, as it does to The Honorable and Mrs. John M. Allison, Miss Adelaide de Menil, Mr. and Mrs. Jean Riboud, and Mr. and Mrs. Gilbert H. Kinney.

In Paris, the Association Française d'Action Artistique, with the encouragement of the distinguished critic and author, Mr. Gaston Diehl, has made a significant gift in support of this valuable international project.

The encouragement and the active participation offered by Gordon B. Washburn, Director of the

Asia House Gallery, during most of the preparation of this exhibition cannot fail to be mentioned; nor those of Mr. Laurence Sickman, Director of the Nelson-Atkins Gallery of Art in Kansas City, Missouri, who played such an important part in the selection of the objects to be shown, when he traveled to Paris for this purpose; or of Mr. René-Yvon Lefebvre d'Argencé, Director and Chief Curator of the Asian Art Museum of San Francisco: The Avery Brundage Collection.

To many distinguished French institutions and personalities a very special acknowledgment must be offered, particularly to the Direction Nationale des Musées de France which, in according official permission for this important international loan, deserves the thanks of the Society.

Senator Louis Gros, President of the Commission on Overseas Scientific and Cultural Relations of the Senate of the French Republic, and his five Senatorial colleagues were instrumental in the formulation of the idea of this exhibition when they visited the United States in January, 1971. The Honorable Mr. Henri Claudel, at that time Consul-General of the French Republic, and Dr. Jean-Hervé Donnard, then Cultural Counselor of the French Embassy, assured the materialization of the concept by putting into motion, with astonishing speed, the diplomatic machinery which was to assure official French participation in the project. Mr. Philippe Martial, Administrator of President Gros' Commission, himself a keen amateur of Oriental art, opened many doors in Paris at the beginning of the Society's negotiations with French officialdom and deserves the Society's thanks.

The most tireless participation in the Society's official dealings with France over the four years of the project's gestation has been that of Mr. François Guillot de Rode, Head of the Art Department of the French Cultural Services in New York. His always ready sympathy, his immediate and constant assistance at every turn of events, and his dedication to better artistic understanding between France and the United States, have made him an ally of enormous value in this transatlantic venture.

The Secretary to the Society's Board of Trustees, Winthrop R. Munyan, Esq., and Mrs. Munyan, acting as friends of the cause in New York and Paris, have also given generously of their time and substance to the realization of the project. Miss Frances Washburn, in Paris, was also most helpful in communicating with the Musée Guimet staff on our behalf.

The Gallery's staff has labored valiantly, and again brilliantly, under both Mr. Washburn and their new Director, Mr. Allen Wardwell, in the preparation of the exhibition, its tour to Kansas City and San Francisco, and its catalogue.

To all, the Society expresses its deep gratitude.

Lionel Landry
Executive Vice President
The Asia Society

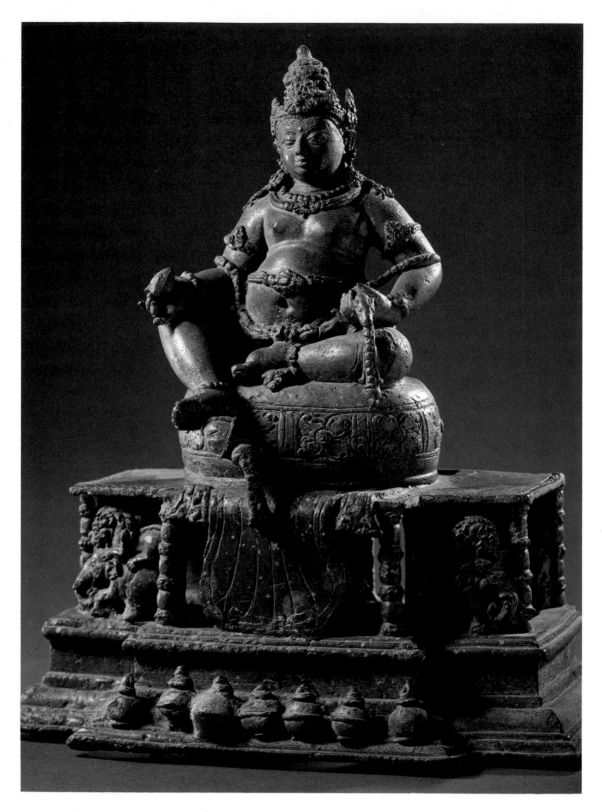

30. Jambhala. *Central Java; ca. ninth century. Bronze, with dark green patina;* H. 11 *in.*

Introduction

THE Musée Guimet in Paris is one of the richest treasuries of Asian art in the world, housing collections that represent all of south-central and far eastern Asia with the exception of Iran. The most remarkable, unquestionably, are those relating to Khmer art (sixth–thirteenth century), to the Hellenistic-Buddhist styles of Afghanistan (second–seventh century), to the styles of ancient Chinese Turkestan (seventh–tenth century) and Tibet (fifteenth–eighteenth century), as well as the ceramic art of China. In every case, these are the largest and rarest collections of their kind in the world. They include groups of very high quality; for example, the Indian bas-reliefs from the Amaravati region (first–third century), the ancient bronzes of central Java (eighth–ninth century), and the dry lacquer items from Nara in Japan (eighth century), to name but a few.

The works here presented to the American public have been selected, with my complete agreement, by Mr. Laurence Sickman, and were chosen with the aim of showing some of the masterpieces preserved in the Musée Guimet. Unfortunately it was necessary to omit objects too fragile or too large and heavy for easy transportation. Nonetheless, we trust the objects on display will be good ambassadors to lovers of Asian art and will be deemed worthy of interest.

On the occasion of this exhibition, we thought it would be interesting to retrace briefly the history of the Musée Guimet, considering it as a phenomenon typical of the evolution of the European taste for Asian art. The story of the Guimet collection can also be viewed as an example of a private assemblage which, as time passed, became a public collection and, finally, a part of the national heritage. The course of its own development perfectly reflects the developing taste of the collectors and connoisseurs to whom it owes its existence and its expansion, for it is only right to add that, although its creation may be attributed to the vision and efforts of one man, Emile Guimet, its founder, the museum's growth and vitality are the result of the intelligence and devotion of countless men and women who knew how to continue Guimet's work after his death. Benefiting from the means placed at their disposal, widening and deepening their acquaintance with these arts of the Far East, and with the techniques of archaeology, conservation, restoration, and improved museum methods, they brought the founder's hopes and plans to fruition.

Prelude to the Musée Guimet

It was not until the second half of the nineteenth century that true collections of Asian art were formed in France, although for more than a century Oriental "curios" had been collected for their strangeness, their exotic qualities. Marie-Antoinette placed sufficient value on the Japanese and Chinese objects in her possession to have them carefully packed in cases on October 10, 1789, and to entrust them, along with her

other valuables, to the jewelers Daguerre and Lignereux, who concealed them until 1793. Some of those objects, which had been divided among seven packing cases, are now preserved in the Louvre, Versailles, and Guimet museums, notably a number of Japanese lacquer boxes which may have been given to the Queen in 1779 by her mother, the Empress Maria-Theresa of Austria.

In the first half of the nineteenth century, the taste for Oriental objects became more widespread but was still undiscriminating. The strange and unfamiliar aspect of the object was more appreciated than was its inherent beauty, and little importance was attached to its age, which was either poorly evaluated or completely unknown.

Scholarly studies, notably in the field of philology, which made it possible from about 1750 onward for the erudite to become familiar with the Orient and the Far East, had no audience among collectors. Two years after the founding of the Bengal Asiatic Society, in 1784, the Frenchman Anquetil-Duperon had begun the teaching of Indology, and in 1795 the Ecole nationale des Langues orientales vivantes was founded in Paris. In 1814 the first Chair of Sanskrit was inaugurated at the Collège de France; four years later Sanskrit was taught in Germany. In 1822 there came into being the Société asiatique de Paris and in 1823, that in London. In 1832 the study of Sanskrit was initiated at Oxford University, and by this time the study of Chinese, which had begun several decades earlier, had become widespread in Europe.

Emile Guimet, the founder of the Musée Guimet, was born in Lyon, in 1836—the son of Jean-Baptiste Guimet (1795–1871), research chemist and inventor of a synthetic ultramarine blue, and Zélie Bidault, a painter, the daughter and niece of painters well known in that period. From these parents he received many natural endowments; gifted in science and industrial technology, he also cultivated the arts—letters, music,

Emile Guimet

ceramics, painting. A composer of trios, quartets, oratorios, and operas, he was equally enamored of archaeology, philosophy, and the history of religions.

In 1865, at the age of twenty-nine, he made his first voyage to Egypt, and from then on was a collector of mummies, statuettes, and steles. He read Champollion (who had deciphered Egyptian hieroglyphics in 1821) and Georges Maspero (another great French Egyptologist and contemporary). Then he became interested in India, China, and Japan. In 1876–77 he journeyed around the world, assigned to a scientific mission by the Ministry of Public Instruction. His purpose was to study the history of religions. From this long voyage he brought back large groups of objects and works of art, including small models and figurines, ethnographical material, some valuable sculptures, ritual objects, manuscripts—in a word, all that might illustrate or explain religious belief or cults. He began by installing these collections in his home in Lyon. But other objects were brought to him, he allowed himself to be tempted—soon he was forced to think of housing the collection elsewhere. Thus it was that Emile Guimet built a museum in Lyon which he donated to that city upon its dedication, on September 30, 1879, by Jules Ferry, the Minister of Public Instruction.

The Musée Guimet of Paris, Its Foundation and Its Era

The establishment in Lyon was merely a first stage in the museum's evolution. Emile Guimet, while managing his father's business, remained a passionate collector and he decided to found another museum, in Paris. A law passed in August, 1885, accepted his gift to the French State. The city of Paris paid one million francs for a parcel of land on the Place d'Iéna for the erection of a museum there. Emile Guimet agreed with the State to assume half of the cost of construction. The museum was to bear his name, and he was appointed as Director for his lifetime. Inaugurated on November 20, 1889, by Sadi Carnot, President of the Republic, the building was opened to the public the following day.

The architectural design was modeled after that of the Musée Guimet in Lyon, the exterior being exactly the same, and expressed the taste of the time—for pomp in the classical style. Surrounding it, along the Rue Boissière and the Avenue d'Iéna, Guimet had provided for a planting of exotic trees—gingkos, Japanese pines, bamboos, a mulberry tree—most of them brought from the greenhouses of his Fleurieu estate in the Rhône department. The city's gardeners have managed to preserve them to the present time.

As for the museum itself, which was arranged in accordance with the prevailing taste, from the beginning it took on the aspect of an institution of learning, an effect Emile Guimet had tried to achieve earlier in the Lyon museum. He has written that, in the course of his visit to America, he was inspired by the Smithsonian Institution* and he used this example in forming the concept of his own museum. He wanted his collections always to be accompanied by all the information available that would deepen and broaden the public's knowledge of the religions and civilizations that had produced these works of art. He placed his own private library in the museum; initially it comprised 13,000 volumes, but soon increased to 15,000. This library was at the disposal of the public and scholars. Free lectures were given each year in the lecture hall of the museum. Popular and scholarly papers were assembled and published under the title *Annales du Musée Guimet*. Emile Guimet also, at this time, founded a journal, *Revue de l'Histoire des Religions*.

*Founded in 1846.

The Musée Guimet

During the period when the Guimet museums were created, first in Lyon, then in Paris, there was a growing interest in the art and religions of the Far East, and many other collectors shared the enthusiasm of Emile Guimet. Listing these collectors chronologically, the outstanding ones were Adolphe d'Ennery (1811–1899), Henri Cernuschi (1821–1896), and Georges Labit of Toulouse (1868–1899). Each of these men bequeathed a museum to his native town or to the Republic.

The eighteenth-century taste for "chinoiserie" and "japonaiserie" survived, but it was transformed by the desire for greater knowledge and understanding. This interest encouraged Edmond de Goncourt (1822–1896) to publish, one after another, his three books on Japanese art: *Outamaro* (1891), *L'Art japonais* (1893), and *Hokousai* (1896). The public's desire for more information was also, as Emile Guimet often declared, the reason for his primary rule—"to make known" (in his words, *faire connaitre*).

Simultaneously, another great collector, Ernest Grandidier (1833–1912), was gathering a remarkable group of Chinese ceramics, which he donated to the Louvre in 1894, when he published his great work on the subject.

The antique dealers, who were as much collectors as merchants, procured for their enlightened customers, lovers of Oriental art, the objects they coveted. Among these antiquarians were Philippe Sichel, L. Heliot, S. Bing, and Mme. Langweil. And we must not forget Chien Tsai Loo, a Chinese who imported the first archaic jades from China in 1912, thus enabling Dr. G. Gieseler to assemble a fine collection which, twenty years later, he donated to the Musée Guimet.

14

Since the operations of the Guimet factory in Lyon required close supervision, Emile Guimet resided nearby, at Fleurieu; he thus engaged a scientific and technical staff to manage the Paris museum, while he directed it with all the firmness that might be expected of an industrialist. The first curator appointed by Emile Guimet was Léon de Milloué; following him, from 1906 to 1923, was Alexandre Moret (1868–1938), the famous Egyptologist. In 1907 Joseph Hackin (1886–1941) became the secretary of the museum, thus beginning a long and splendid career.

The period before World War I was a brilliant epoch for the museum: scholarly meetings alternated with fashionable receptions. In contrast, the years that followed were, as everywhere, quiet and somber. In 1914 Joseph Hackin was promoted to the position of assistant curator, but in 1914 the army claimed him and he departed for the front.

In 1918 Emile Guimet died.

The Years Between the Two World Wars

A second phase in the Musée Guimet's history began after the Armistice. In 1923, when the museum's curator, Alexandre Moret, was elected to the Collège de France, Joseph Hackin was promoted to the position of curator. Then, in 1925, the museum was legally attached to the Réunion des musées nationaux de France.

At that time René Grousset (1885–1952) was assistant curator, and Philippe Stern, who had been working as an unpaid volunteer for the museum, was invited to become a member of the staff. Stern was, in addition, designated curator of the Musée Indochinois du Trocadéro. With this new team, the Guimet entered a period of great activity. While the lecture programs and publications continued, the library grew, thanks to donations, bequests from the estates of Emile Senart and others, and purchases. The library was made even more useful with the addition of an impressive photographic archive. Complete series of negatives depicting the missions of Edouard Chavannes in China, Paul Pelliot in Chinese Turkestan, Victor Goloubew in India and Java, and others were given to the museum, where they remain to the present day.

As for the collections of objects, they underwent a profound change. The already important collections of original works of art were reclassified. These included superb examples of Khmer art received from archaeological missions before 1900, paintings and objects from Central Asia brought back by Paul Pelliot in 1910, and Tibetan paintings and bronzes donated by Jacques Bacot in 1912, to name but a few. While following the line of studies laid down by Emile Guimet—the history of religions—the curators were now trying to replace certain purely documentary material with objects of greater artistic value. This transformation of the Guimet collections followed closely the evolution of public taste and even, in many respects, directed that evolution. The change in the character of the collections was made possible by generous and repeated contributions from various archaeologists and explorers (missions of Alfred Foucher in 1923, Joseph Hackin beginning in 1924, Jules Barthoux in 1926–28 in Afghanistan, and others), as well as by donations, notably from J. J. Meijer (1922), and C. T. Loo (1927 and almost every year thereafter).

At the Louvre, under the stimulus of Raymond Koechlin (1860–1931), president of the Conseil artistique des Musées Nationaux, the department of Oriental arts experienced a similar leap forward. In

1926 Georges Salles (1889–1966), who was later to play a major role, was named assistant curator and also began to teach courses in Muslim and Sino-Japanese art while occupying a newly created chair at the Ecole du Louvre. Three years later a chair of Indian and related arts was founded and linked with the curatorships of the Musée Guimet: Joseph Hackin, René Grousset, and Philippe Stern taught for three-year terms, in rotation.

In 1931 (when the Colonial Exposition was held at Vincennes), the Musée Guimet presented to the Parisian public an entirely new installation in a completely renovated setting. Four collections were featured: Khmer art, augmented by numerous original pieces transferred from the Musée Indochinois du Trocadéro; the Hadda stuccos from Afghanistan; bronzes and paintings from Tibet; paintings, wood sculptures, and *terres séchées* (dried earth overlaid with plaster) from Chinese Turkestan. By this time the Indian section had been notably enriched, whereas the weakest points remained the Chinese and Japanese collections.

Between 1931 and 1937, when the international exhibition "Art and Technique" was held in Paris, the Guimet widened its scope still more and underwent another transformation. The museum had received some important donations: Dr. G. Gieseler had given his precious archaic jades, setting up the displays, with the aid of his wife, in new vitrines; C. T. Loo had considerably augmented the collections from India; Joseph Hackin had brought back from his Afghanistan missions (1933–37) some exceptional treasures—carved ivories and bronzes from Begram, *terres séchées* from Fondukistan, etc. Expenditures authorized under the State budget permitted the purchase of important works of art and augmented the funds of the library and the photographic archives. The latter received, in addition, masses of documents from the Ecole Française d'Extrême-Orient. The inner court of the Musée Guimet was built, and transformed into a hall to contain the Khmer statues; their numbers had been increased by some fine pieces, sent by the EFEO following Philippe Stern's 1936 mission to Cambodia. A large lecture hall was constructed in the basement, and the rest of the museum was entirely renovated. These new installations and facilities were opened to the public by Albert Lebrun, the President of the Republic.

Thus, during this whole period and indeed until World War II, the museum was as brilliantly active as it had been during Emile Guimet's lifetime. Besides the usual lectures and conferences, there were monthly afternoon teas that were attended by the most eminent French orientalists. These receptions were given either by the curators or by the Association française des Amis de l'Orient, founded in 1922 and directed at this time by Jean Buhot, specialist in Japanese art. Present at those teas were Sylvain Lévi, Paul Pelliot, Henri Maspero, Jules Bloch, Alfred Foucher, Jacques Bacot, Paul Mus, Pierre Dupont, Emile Gaspardone, Paul Demiéville, Louis Renou, Jean Filliozat, Jean Sauvaget, Charles Haguenauer, Victor Goloubew, Jean Przyluski, Gilbert de Coral Rémusat, and many others. And between two trips to Afghanistan, Joseph Hackin played the role of host—on those days, jasmine tea that he had brought back from his most recent expedition to Asia would be served. He was helped in his duties by René Grousset and Philippe Stern, and by a whole group of enthusiastic young people who were well aware of the privilege of talking to these amazing men, who treated them as future colleagues.

World War II ruthlessly interrupted the museum's growth. French orientalism lost seven of its most celebrated representatives, among them Joseph Hackin and his wife, whose lives were sacrificed for France in February, 1941, and Henri Maspero, who died as a deportee. The collections were evacuated

from Paris to safety in the provinces. The services, greatly reduced because only a few staff members remained, continued to function at a slackened pace under the direction of René Grousset and Georges Salles.

The Musée Guimet as the Department of Asian Arts

In 1941, Georges Salles, at that time the curator of the Musée Guimet, in connection with René Grousset, who was named chief curator of both the Cernuschi and Guimet museums, proposed that the Asian collections at the Louvre be combined with those of the Guimet. A decree of Marshal Pétain confirmed this proposal, which was ratified in 1945, when Georges Salles had just been appointed director of the national museums of France. Immediately after the Liberation the national collections were brought back to Paris; the Asian collections of the Louvre were installed at the Place d'Iéna, while the Egyptian objects that Emile Guimet had collected were transferred to the Louvre.

Room of Japanese prehistoric art

Room of post-Gupta Indian sculpture

This regrouping marked an important stage in the history of the Musée Guimet: the massive contributions issuing from the Louvre required that the collections be presented in an entirely new manner. Philippe Stern, who had taken refuge in the provinces during the German occupation of France, now undertook this task. To the already rich resources of the museum, the Louvre deposits added the four thousand Chinese ceramic pieces in the Grandidier collection; many examples of archaic bronzes, sculpture, and paintings from China; a group of Japanese dry lacquers and screens, and an extensive collection of prints; Indian miniatures; as well as many of the objects brought back from Chinese Turkestan by Paul Pelliot (only half of these had been donated originally to the Musée Guimet). The names of those who had given works of art to the Louvre were now added to the list of donors to the Musée Guimet: they were Raymond Koechlin, Nissim de Camondo, Henri Vever, Charles Vignier, S. Bing, C. Jacquin, Gaston Migeon, Alexis Rouart, Robert Lebaudy, David David-Weill, Charles Gillot, L. Wannieck, Atherton Curtis, and others.

A very careful selection was made of the works to be displayed, based on the highest standards of rarity and quality. Nothing was to be exhibited that did not meet these criteria. The remaining objects were classified as reserves and stored, to be available for study or exchanges.

Each year between 1947 and 1950 witnessed the opening of a new floor of the museum, presenting new displays which included the latest contributions from Joseph Hackin's excavations in Begram (1939–40), which were brought to the museum only after the Liberation—Indian ivories, glass, Hellenistic works in plaster. In 1952 a new lecture room with the most up-to-date technological equipment, seating 360, was inaugurated. Also, during this period, agreements made before the war concerning the exchange of objects with the national museums in Bangkok and Tokyo were put into effect.

At this time the Musée Guimet acquired an annex in a nearby building purchased for it by the State. All the objects that were primarily of iconographic interest were transferred there, classified, and placed in the study reserves. Also installed in the annex was the Centre de Documentation des IVe et Ve sections de l'Ecole pratique des Hautes Etudes, whose directors, on many occasions, established the theme and the plan of exhibitions which were arranged by the curator in charge of the annex, Mme. Henriette Bernard. These temporary exhibitions, which often remained on view for some time, illustrated special themes, such as "Cosmic Symbolism and Religious Monuments," "The Mask," "Emblems, Totems, and Banners." Thus the dreams and aims of Emile Guimet, who wished to link the objects directly with scholarly studies, were realized.

In 1952, Réne Grousset was stricken with a serious malady and died. From 1954 to 1965, Philippe Stern served as chief curator of the Musée Guimet. These were years of great activity and accomplishments in every area: lectures, the enrichment of the collections, the expansion of documentary services, the presentation of quarterly exhibitions, and so on.

A new phase, which is still in progress, began in 1965, when the director of the museums of France, Jean Châtelain, decided to include the Guimet among the important projects of the Fifth and Sixth National Plans. For a long time the curators had sought to enlarge their precincts. Now the solution to the problem had been found, and in 1967 construction was begun. A first section was finished by the end of 1972 and on December 19 was opened officially by Jacques Duhamel, Minister of Cultural Affairs. When completed, the new premises will provide an additional two thousand square meters of space for the collections, the library, the audio-visual archives, and the conservation services.

Thus the work begun by Emile Guimet has expanded and developed. A private collection, necessarily limited, has been transformed into a great museum directed by the State, which is responsible for it. Conceived by one individual, it has become a collective enterprise in which curators and donors work with equal enthusiasm for its success. The financial support of the State, which has been unfailing, should make it possible to sustain the position the Musée Guimet has held from its creation: as much a study center as a museum of Asian art worthy of the name.

Jeannine Auboyer
Chief Curator of the Musée Guimet

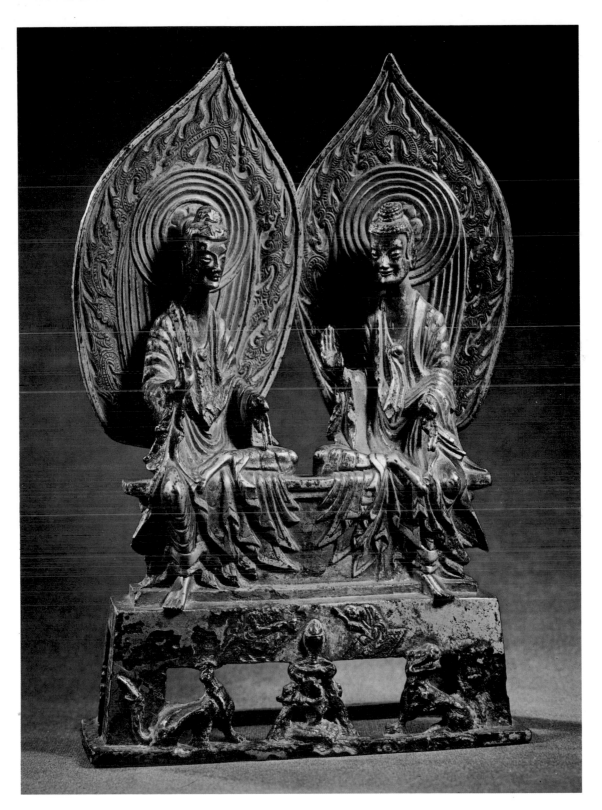

61. Śākyamuni and Prabhūtaratna. *China;* A.D. 518. *Gilt bronze;* H. 10¼ *in.*

Contributors to the Catalogue

The information in this catalogue has been provided by the following members of the staff of the Musée Guimet:

AFGHANISTAN AND PAKISTAN
Mme. Francine Tissot, *Chargée de Mission*

INDIA
Mlle. Marguerite-Marie Deneck, *Curator*
Mme. Andrée Busson, *Chargée de Mission*

SOUTHEAST ASIA
M. Albert le Bonheur, *Curator*

NEPAL AND TIBET
M. Gilles Béguin, *Curator*
Mlle. Marie-Thérèse de Mallmann, *Chargée de Mission*
Mme. Chantal Massonaud, *Chargée de Mission*

CHINA AND CENTRAL ASIA
Mme. Michèle Pirazzoli-t'Serstevens, *Curator*
Mlle. Madeleine Paul-David, *Chargée de Mission*
Mme. Daisy Lion-Goldschmidt, *Chargée de Mission*
M. Hou Ching-lang, *Collaborator*
Mme. Françoise Denes, *Chargée de Mission*
M. Robert Jera-Bezard, *Chargé de Mission*

Each catalogue entry is followed by the initials of the person who supplied the information.

Catalogue and Plates

Afghanistan and Pakistan: Sculpture, Gandhāra Style

Gᴀɴᴅʜᴀ̄ʀᴀ, Afghanistan, France, and the Musée Guimet share cultural and emotional ties. Their relations have been enlivened by the entertaining and dramatic events that make up the long story of a classical and traditional culture—brought to light in the course of unearthing together the former civilizations of Central Asia. After the day in 330 B.C. when Alexander the Great entered Afghanistan with his soldiers, scholars, and artists, nothing was ever the same again (see Mortimer Wheeler's *Flames Over Persepolis*). Upon leaving Indian soil three years later, he left everywhere a new form of political and cultural life which, little by little, became adopted by the people—rich and poor, kings and merchants—who had previously been dedicated to the hard law of the neolithic.

The first French archaeologists who left the Musée Guimet, with texts in hand, for the Afghan deserts and the Khyber Pass wanted to find the traces of Alexander. On their path they found a hybrid art, not really Indian, not entirely Greek, whose ruined monuments the English soldiers—stationed in Northwest India (now Pakistan)—discovered in the course of their patrols. Alfred Foucher (1865–1952), among others, understood the importance of this art, called Greco-Buddhist, which we now call the art of Gandhāra. Recent excavations by Soviet scholars in ancient Russian Turkestan indicate that its origin must be sought in Hellenized Bactria, where "Greek," Saka, Parthian, and Kushan kings constructed, from the second century B.C. to the first century of our era, palaces and dynastic temples, acropolises and necropolises. The French Archaeological Delegation in Afghanistan discovered in the area corresponding to ancient Bactria a Hellenistic town, Ai-Khanoum, and a dynastic temple, Surkh-kotal (excavations of Daniel Schlumberger and Paul Bernard). Gandhāra art, however, is first of all a Buddhist Indian art, all the more important because it was the first to represent the Buddha as a man.

Indeed, in the first century B.C. in Northwest India, the Theravāda Buddhists had effected a profound reform of the ancient religion and had spread the Mahāyāna or Great Vehicle of the Law. It is possible that the new devotees or the catechized barbarians needed icons in order to understand the new faith. These icons are the Gandhāra Buddhas and Bodhisattvas, the princes, perhaps deified, the narrative reliefs, and the heads that are now in the museum's collection. They are the familiar décor of the stupas and the chapels of monasteries that marked the route of the pilgrims and missionaries who carried the new religion toward Bactria, Tarim in Central Asia, China, and Japan, from the second century onward.

The Gandhāra collection of the Musée Guimet was brought back from Peshawar in 1910 by Foucher. The pieces, carved of gray-blue schist, of various sizes, relate the episodes (*jātakas*) of the life of Śākyamuni Buddha and his previous incarnations. The familiar themes are marked by Hellenistic, Iranian, and Indian influences.

The museum's Afghan collection includes, among many other pieces, an admirable group of stucco sculptures brought back from Hadda by J. Barthoux in 1928. They are the decorations of the thousand

stupas described by the Chinese pilgrim Hsüan Tsang in the seventh century, and were brought to Paris thanks to an agreement signed by the king of Afghanistan and the French Archaeological Delegation in Kabul.

Now that the objects from the Musée Guimet are serving as traveling ambassadors of the art of these countries, and as messengers of the efforts of French archaeology, it is fitting to recall the advantages and pleasures of these generous international exchanges.

Francine Tissot

1 THE "FOUCHER" BODHISATTVA AO 2907
Pakistan, Shabaz-garhi;
ca. second century
Gray schist; H. 47¼ in. (120 cm.)

In the Mahāyāna iconography, a Bodhisattva is a holy man or a prince who, after having attained Buddhahood through his merits, renounces it to dedicate himself to the service of man. Here the Bodhisattva Siddhārtha, the historical founder of Buddhism, is dressed as a prince of India with a dhoti, a shawl of fine, draped cloth, and a turban. But the jewels of the turban, the necklaces, the bracelets, and even the sandals are strangely decorated with minor subjects of Scythian or Sarmatian inspiration, in gold or in semi-precious stones. However, the *urna* (whorl of hair) between the half-closed eyes and the webbed hands indicate that the prince already dwells in the Buddhist realm. This statue was in the first Gandhāra collection brought by Alfred Foucher to the Department of Oriental Antiquities in the Louvre. (F.T.)

Published: A. Foucher, *L'Art du Gandhara* (Paris, 1905), vol. I, frontispiece; R. Grousset, *Inde* (Paris, 1949), fig. 38; *Trésors de l'art de l'Inde* (Paris, 1960), no. 140; M. Hallade, *Inde* (Fribourg, 1968), fig. 68; *Gime Tōyō Bijutsukan* (Tokyo: Kodansha, 1968), pl. 49.

2 TWO SCENES OF THE LIFE OF MG 17443
BUDDHA
Afghanistan, Hadda; ca. third century
White limestone, with traces of
polychromy; H. 14½ in. (37 cm.),
W. 9½ in. (24 cm.)

This fragment of an illustrative stele bears two superimposed scenes that are separated by and framed with decorative motifs of Hellenistic inspiration. The lower scene represents the first preaching of the Buddha in Banaras; the upper one, the story of the offering of the handful of dust to the Buddha by two young children. This relief, brought back in 1928 by Jules Barthoux, perhaps comes from Chakhil-i-ghoundi, one of the few monasteries of Hadda where limestone sculptures are to be found. (F.T.)

Published: Hallade, *Inde*, fig. 95.

3 THE GREAT DEPARTURE MG 17189
Afghanistan, Hadda, Stupa 71 of
Tapa Kalan monastery;
ca. fourth–fifth century
Stucco; H. 11¾ in. (30 cm.)

Between the Bodhisattva Siddhārtha seated on the left and his wife, Yaśodharā, sleeping on the right, the squire Chandāka appears in foreign guise, as Destiny had decreed, bringing him his traveling head-gear. The prince is about to abandon his wife, son, and riches to live the life of an ascetic and then become the Buddha. (F.T.)

Published: J. Barthoux, *Hadda*, vol. III (Paris, 1930) pl. 46; Hallade, *Inde*, fig. 109; J. Auboyer, *L'Afghanistan et son art* (Prague, 1968), fig. 59; *Gime Tōyō Bijutsukan*, pl. 56.

4 MONK CARRYING FLOWERS MG 17328
Afghanistan, Hadda, Stupa 68 of
Tapa Kalan monastery;
ca. third–fourth century
Stucco, with light traces of
polychromy; H. 13 in. (33 cm.)

This is one among the hundreds of monks that appear in the reliefs of votive stupas. His hands hold a tray laden with flowers. His ecstatic expression indicates his devotion to the Buddha. This is a beautiful example of clinging drapery. (F.T.)

Published: Barthoux, *Hadda*, vol. III, pl. 39 d.

5 HEAD OF AN ASCETIC MG 17118

Afghanistan, Hadda, Stupa 68 of
Tapa Kalan monastery;
ca. third–fourth century
Stucco, with traces of red paint;
H. 7⅞ in. (20 cm.)

The large sunken eyes in an emaciated face, slightly orientalized by the tiny chignon of long straight hair, and the distended ears, are the features of an ascetic absorbed in a spiritual world. (F.T.)

Published: Barthoux, *Hadda*, vol. III, pl. 64 a; O. Monod, *Le Musée Guimet* (Paris, 1966), fig. 183.

6 HEAD OF A BARBARIAN MG 17282

Afghanistan, Hadda, Stupa 68 of
Tapa Kalan monastery;
ca. third–fourth century
Stucco, with traces of red paint;
H. 4 in. (10 cm.)

This portrait of a foreigner involved in the monastic life, probably a donor, whose drooping mustache and curly hair identify him as being of Scythian origin, is an example of the various ethnic types that passed across the Northwest frontier. (F.T.)

Published: Barthoux, *Hadda*, vol. III, pls. 47 a and a′; Monod, *Le Musée Guimet*, fig. 185.

7 HEAD OF A BARBARIAN MG 17133

Afghanistan, Hadda, Stupa 67 of
Tapa Kalan monastery;
ca. third–fourth century
Stucco; H. 4¼ in. (11 cm.)

This bearded face, whose knotted and looped hair seems to be tossed by the wind of the steppes, evokes the dark presence of one of the giants shown on the Altar of Pergamum. (F.T.)

Published: Barthoux, *Hadda*, vol. III, pls. 61 a and a′; Monod, *Le Musée Guimet*, fig. 191; Auboyer, *L'Afghanistan et son art*, fig. 62.

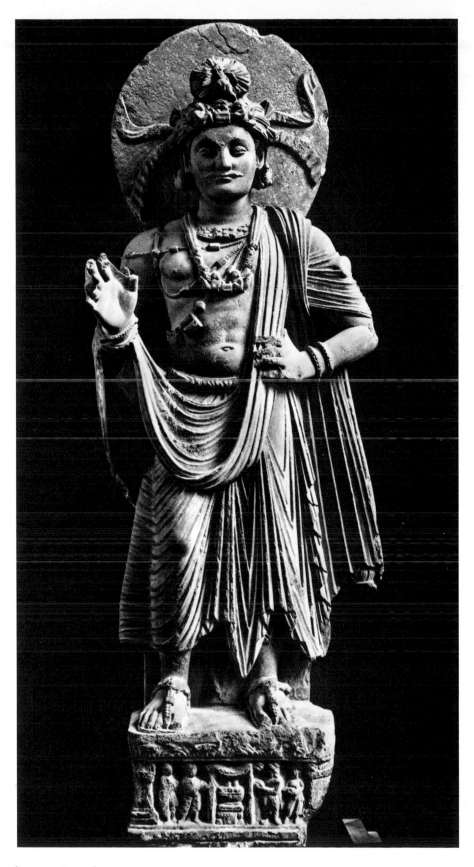

1. The "Foucher" Bodhisattva. *Pakistan; ca. second century. Gray schist; H. 47¼ in.*

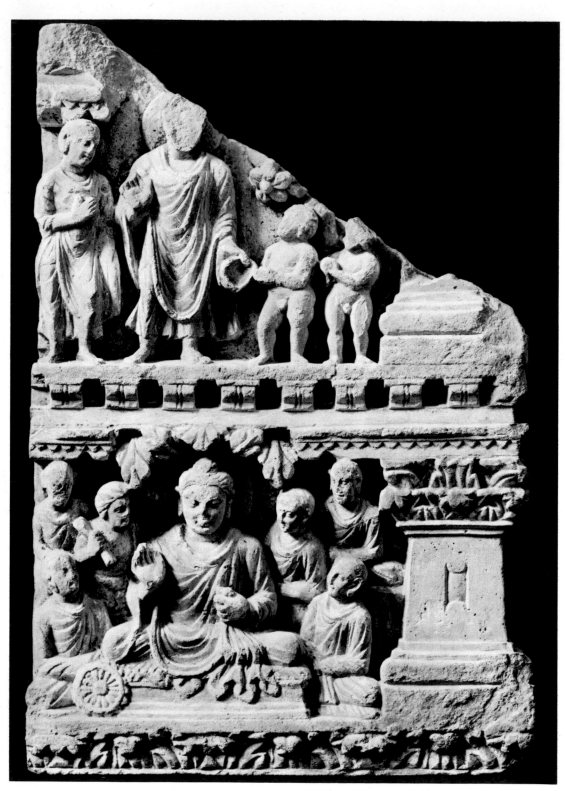

2. Two Scenes of the Life of Buddha.
Afghanistan; ca. third century. White limestone, with traces of polychromy; H. 14½ in.

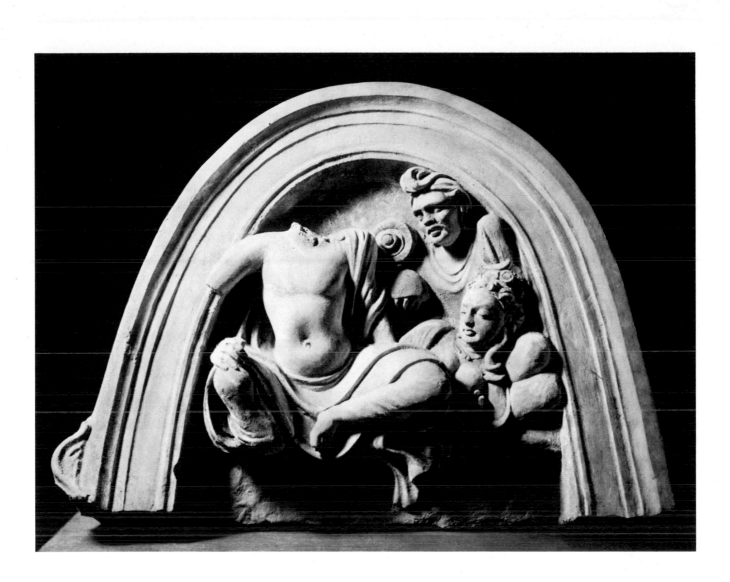

3. The Great Departure. *Afghanistan; ca. fourth–fifth century. Stucco;* H. 11¾ in.

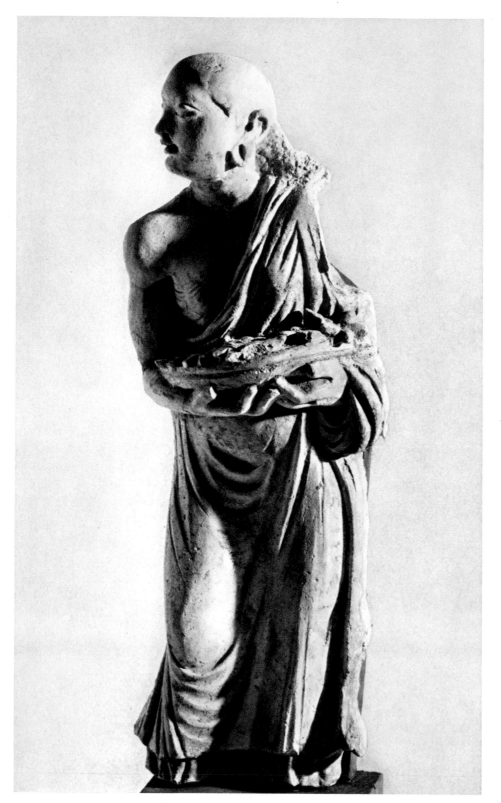

4. Monk Carrying Flowers. *Afghanistan; ·ca. third–fourth century. Stucco, with light traces of polychromy;* H. 13 *in.*

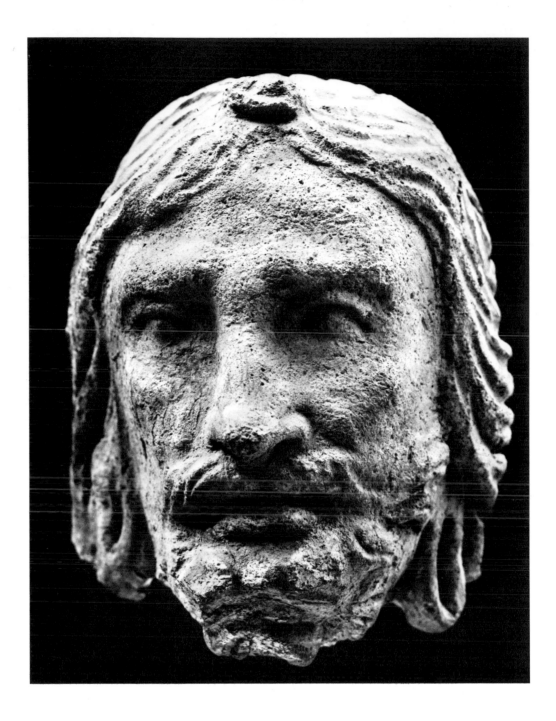

5. Head of an Ascetic. *Afghanistan; ca. third–fourth century. Stucco, with traces of red paint;* H. 7⅞ *in.*

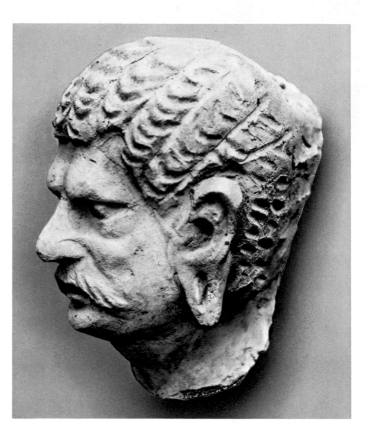

6. Head of a Barbarian
Afghanistan; ca. third–fourth century
Stucco, with traces of red paint; H. 4 in.

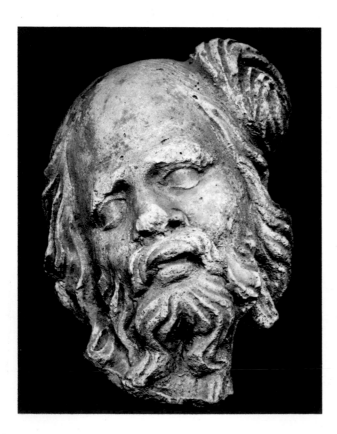

7. Head of a Barbarian
Afghanistan; ca. third–fourth century
Stucco; H. 4¼ in.

30

India: Sculpture

THE first Indian collections of the Musée Guimet were primarily iconographic in nature, in accordance with the intentions of Emile Guimet, who had founded a museum of religions. They included a majority of bronzes and wooden chariot decorations from South India, works dating for the most part from the nineteenth century. Beginning in 1925, these collections were enriched by objects of artistic and archaeological interest from the region of Mathura (gifts of C. T. Loo and C. Vignier), and from South India (gifts of Jouveau-Dubreuil and C. T. Loo), Buddhist reliefs from the region of Amaravati and Dravidian bronzes. From then on the curators of the Guimet worked to complete these collections, acquiring pieces from Bengal, Orissa, Rajasthan, and receiving new gifts—pieces in the Śunga style (Densmore gifts) and slabs from the temple of Harwan in Kashmir (gift of the Maharaja of Kashmir), among others. In 1961, thanks to an exchange with the Archaeological Service of India, five works of the Gupta style were acquired; the Guimet had previously owned only a small head of the Bodhisattva Avalokiteśvara, a gift made in 1936 from the Société des Amis du Musée Guimet.

Marguerite-Marie Deneck

8 SERPENT-KING (Nāgarāja) MG 18214
Mathura School; second century
Rose sandstone; H. 45¾ *in.* (116 cm.)

This piece is remarkable for its spiritual vitality and harmonious lines. The Nāgarāja, spirit of the waters, leans against the coils of a serpent curled up behind him, his hips swayed to the left and his right leg slightly flexed. The position of the nude torso indicates that the missing right arm was raised to the sky in a gesture calling for the life-giving rain. He is clothed in a dhoti made of a light, transparent fabric that falls in a mass of folds between his legs. A cloth belt holds the garment on his hips; it forms two loops on the left, a large knot on the right, and after curving under the right knee, ends in a flap on the left thigh. There is a garland of flowers around his neck and an arm-ring near the left shoulder. The arm-ring decoration consists of a squared pattern between two narrow borders. The coils of the serpent's body are carved on the back, and two of them are visible from the front on the right side. The head, arms, and feet are broken off. (M.-M.D.)

Gift of C. T. Loo, 1932.

Published: O. Monod, *Le Musée Guimet* (Paris, 1966), p. 52, no. 4; *Gime Tōyō Bijutsukan,* pl. 1.

9 RAILING (*Vedikā*) PILLAR OF A MG 17849
STUPA
Mathura School; Kushan period,
ca. second century
Red sandstone; H. 27½ *in.* (70 cm.)

The front surface of this railing pillar consists of a broad-shouldered Buddha whose feet, now missing, were firmly planted on the ground. His right hand is broken but, judging by its position at shoulder height, must have been making the gesture of the absence of fear (*abhayamudrā*); from his left hand the flap of a monastic robe falls in parallel folds the length of the body: The robe reveals, on a diagonal, the right half

of the torso. It clings to the body; its drapery is done in low relief. A belt knotted on the right side holds the undercloth (*antaravāsaka*) in place. The round, shaved head is covered with a skull cap. It has the smiling face and distended earlobes that characterize the Buddha. Encircling the head is a halo, festooned and crowned by a kind of parasol, the sign of royalty.

On the reverse side are two and a half lotus-medallions whose petals are outlined in double lines and whose corners are decorated with lotuses shown in profile. On the sides are three slots in which the cross-bars of the balustrade were placed. The lower part is broken on an angle at the height of the first slot. (M.-M.D.)

Gift of C. T. Loo, 1931.

Published: Monod, *Le Musée Guimet*, p. 50, no. 3; *Gime Tōyō Bijutsukan*, pl. 4.

10 HEAD OF BUDDHA MG 17003
From Vijiaderpuram, near Bezvada (Andhra Pradesh); Amaravati School; ca. second century
Marble; H. 8¼ *in.* (21 *cm.*)

This is a remarkably well modeled head. Distinctive marks of the Buddha are the cranial protuberance (*ushnisha*), which is only slightly visible, and the tuft of hair between the eyebrows (*urna*) in the form of a pellet in relief. Parallel lines are incised between the stylized flat curls of the hair.

In its realism, this head seems to reflect Roman influence, which can be explained by the fact that there were commercial relations between the Roman world and the southeast coast of India during the first two centuries of our era. The writings of ancient historians indicate that such relations existed, and this has been further confirmed by the findings of the French archaeological expedition on the site of Virampatnam near Pondicherry (identified as the "Podouke" of the ancient writers), where fragments of pottery from Arezzo were discovered. Moreover, a Roman coin was found on the same site as this head. (M.-M.D.)

Gift of Jouveau-Dubreuil, 1925.

Published: J. Hackin, *La Sculpture indienne et tibétaine au Musée Guimet* (Paris, 1931), pl. III.

11 RELIEF FRAGMENT MG 17067
From Nagarjunakonda (Andhra Pradesh); Amaravati School; ca. third century
Marmorean limestone; H. 51¼ *in.* (130 *cm.*), W. 37 *in.* (94 *cm.*), DEPTH 5¼ *in.* (13.5 *cm.*)

This relief served as the facing of a stupa. It is divided into two registers by a narrow band of lotus flowers. The upper register, somewhat mutilated, shows one of the scenes in the Life of the Buddha—the sleep of women. The haloed Bodhisattva is seated in the pose of royal relaxation on a throne with a back; behind him a woman holds a fly-whisk; at his right are an attendant and two seated women, one of whom, on a throne with a back, seems to be his wife, Yaśodharā; the other women are asleep in casual positions.

The lower register illustrates a Buddhist tale, the *avadāna* of the man in the well. King Udayana of Kauśāmbī, to the right, rushes forward furiously because his women have abandoned him in order to listen to the ascetic Piṇḍola, who is seated to the left at the foot of a tree. To calm the king, Piṇḍola recites the parable of the man in the well, which is represented on his right. The king, once pacified, is portrayed, seated at Piṇḍola's left, with his hands joined in the sign of respect.

In its dynamic and harmonious composition, making use of various gestures and positions of the figures, and in its details of the clothing and ornaments (headdresses, belts with bead ropes and a short piece of fabric in front, series of bracelets encircling the arms and forearms, and especially the heavy leg anklets), this bas-relief is very characteristic of the Amaravati School of South India. (M.-M.D.)

Gift of Jouveau-Dubreuil and C. T. Loo, 1927.

Published: Hackin, *La Sculpture indienne et tibétaine*, pls. V-VIII; J. Ph. Vogel, "The Man in the Well," *Revue des arts asiatiques*, vol. XI, no. 3, p. 111 and pl. XXXIII b.

12 STANDING BUDDHA P 373
From Sarnath; Gupta style; fifth century
Chunar sandstone; H. 38½ *in.* (98 *cm.*)

This Buddha is leaning on the left leg with the right leg slightly flexed. The head, feet, right forearm, and

left hand are broken off. The monastic costume, made of a light fabric, clings closely to the body and reveals a perfectly modeled form. It is composed of an under-cloth (*antaravāsaka*), visible only in the bulge on the stomach and two groups of folds at ankle height, and a shawl (*saṅghāṭi*) that frames the body. The *saṅghāṭi* is visible in the drapery around the neck opening and the fall of the folds in stylized, zig-zag pleats to the left.

This piece comes from the Archaeological Museum of Sarnath and was found in 1904–5 southwest of the main temple. (M.-M.D.)

Exchange with the Archaeological Service of India, 1961.

Published: Daya Ram Sahni, *Catalogue of the Museum of Archaeology at Sarnath* (Calcutta, 1914), p. 45; O. Viennot, "Nouvelles acquisitions," *Revue du Louvre*, no. 6 (1963), p. 297.

13 HEAD OF BODHISATTVA AVALOKITEŚVARA MG 18646
Gupta style of Mathura; ca. fifth century
Red sandstone; H. *6 in.* (15 *cm.*)

The rather full oval head, with half-smiling, full lips and eyebrows in relief, is characteristic of the Gupta style of Mathura. The headdress is particularly inter-esting. The jeweled headband contains a motif of two sea monsters (*makara*) encircling a rectangular cabo-chon topped with a circle from which the stem of a full-blown lotus juts out. The lotus rests on the trunks of the *makara* and supports a little seated Buddha, who is dressed in a monastic robe that covers both shoul-ders. With his right hand he makes the gesture of charity (*varamudrā*); he is flanked by two horned lions standing on their hind legs, from whose mouths spew forth garlands of beads that knot behind the head and fall on the nape of the neck. (M.-M.D.)

Gift of the Société des Amis du Musée Guimet, 1936.

Published: M. T. de Mallmann, *Introduction à l'étude d'Ava-lokiteśvara* (Paris, 1948), pp. 129, 210, pls. II c and d, XXII c and d.

14 WOMAN HOLDING A CHILD MG 18231
Orissa style; ca. tenth century
Sandstone; H. *16¼ in.* (41 *cm.*)

This fragment of an architectural decoration consists of the figure of a woman, turned three-quarters to the right, raising a child toward a flowering branch which passes behind the two figures. Her face is directed toward him, her left hand resting on his shoulder, her right hand supporting him. She is dressed in a dhoti held on the hips with a jeweled belt; a scarf floats from her shoulders. She wears a large chignon encircled with a triple row of pearls. Her jewelry includes a necklace with three rows of pearls and a pendant, armlets, a series of wrist bracelets, and large, circular earrings. The child, whose head is missing, is also adorned with bracelets and armlets. (M.-M.D.)

Former collection of J. de Belty; acquired in 1910 by the Musée Indochinois du Trocadéro; brought to the Musée Guimet in 1927(?).

Published: Hackin, *La Sculpture indienne et tibétaine*, pl. XXI.

15 TRIDENT (*Triśūla*) MG 17470
From near Tanjore; Chola period, ca. tenth century
Bronze, with green patina; H. *21¾ in.* (55 *cm.*), W. *14¼ in.* (36 *cm.*)

The two outer branches of the trident emerge from the mouths of two *makara* and curve in to join the middle branch. The *makara* are supported on a small pedestal, decorated at the base with a design of lotus leaves and resting on a rectangular platform. Each branch is decorated with a lotus flower of eight petals, and in the middle of the median branch is Māriyatale or Māriyammā, names by which the goddess who protects against smallpox and contagious diseases is known in South India (she is revered in the north as Śītalā devī). Māriyatale, whose hair is bristly, is seated in *lalitāsana* (right leg folded under, left leg hanging). She has four arms and holds a trident in her front right hand; the attribute in the upper right hand, the noose (*pāśa*), is broken; the left front hand holds a skull cup (*kapāla*); and the upper left hand the serpent (*nāga*). This trident, which is carried in processions to exorcise epidemics, evokes both the power of Śiva, which it symbolizes, and the action of Śītalā devī. (M.-M.D.)

Gift of C. T. Loo, 1929.

Published: Hackin, *La Sculpture indienne et tibétaine*, pl. XXVI; J. Hackin, "Cakra et triśūla," *Revue des arts asiatiques*, vol. V, no. 2, p. 65, pl. XVIII.

16 ŚIVA AGHORAMŪRTI MG 18571

Chola period, tenth–eleventh century
Bronze, with green patina;
H. 16¼ *in.* (41 *cm.*)

The god Śiva, in one of his terrifying forms, is represented nude and adorned with jewels—necklaces, bracelets, armlets, anklets, earrings, and belt. His hips are girdled by the body of a serpent whose head is raised. The sacred cord (*yajñopavīta*) is replaced by a double garland of skulls, characteristic of the early Chola period, as is the tassel on the right shoulder. The hair is arranged in a halo forming a border of curls, and bears a human skull and a serpent in the center; to the right is a crescent moon. The forehead is circled by a diadem decorated with rosettes. The god has eight arms, six of which hold his attributes: to the right, from the top, the drum (*ḍamaru*), the magic wand (*khaṭvāṅga*), the sword (*khaḍga*); to the left, the serpent (*nāga*), the noose (*pāśa*), the skull cup (*kapāla*). Round, bulging eyes, frowning brows, and fangs mark the terrifying aspect of the god. (M.-M.D.)

Gift of C. T. Loo, 1935.

Published: C. Sivaramamurti, *South Indian Bronzes* (New Delhi, 1963), pl. 93 b.

17 ŚIVA JÑĀNADAKṢIṆAMŪRTI MG 18519

Vijayanagar period, sixteenth century
Gilt bronze; H. 4¼ *in.* (11 *cm.*)

The god who teaches the *śāstras* is seated with the left leg folded over, the right leg hanging, the foot resting on a dwarf (*apasmārapuruṣa*), symbol of epilepsy and ignorance, who holds a cobra in the left hand. Śiva has four arms. The two upper hands hold, to the right, a rosary (*akṣamālā*) and, to the left, the fire (*agni*); his lower right hand makes the gesture of teaching (*vyākhyānamudrā*). The locks of his hair are symmetrically arranged and are adorned with a skull in the center and a crescent moon to the left. He is clothed in a loincloth held by a belt forming a knot to the right and left, and is adorned with jewels. Stylistically, this bronze is characteristic of the period of the Vijayanagar dynasty, which ruled in South India during the fourteenth to sixteenth century. (M.-M.D.)

Acquired in 1935.

Published: Sivaramamurti, *South Indian Bronzes*, pl. 93 a.

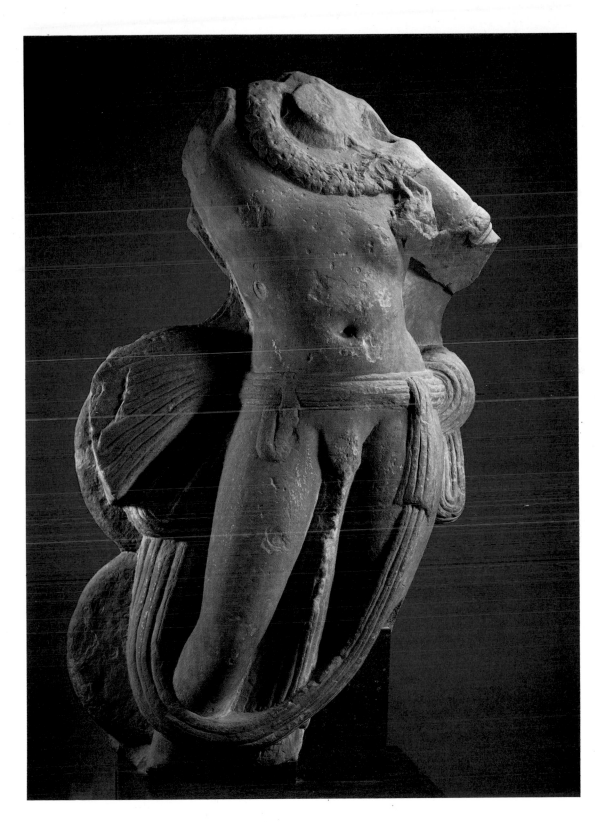

8. Serpent-king (Nāgarāja). *India; second century. Rose sandstone;* H. *45¾ in.*

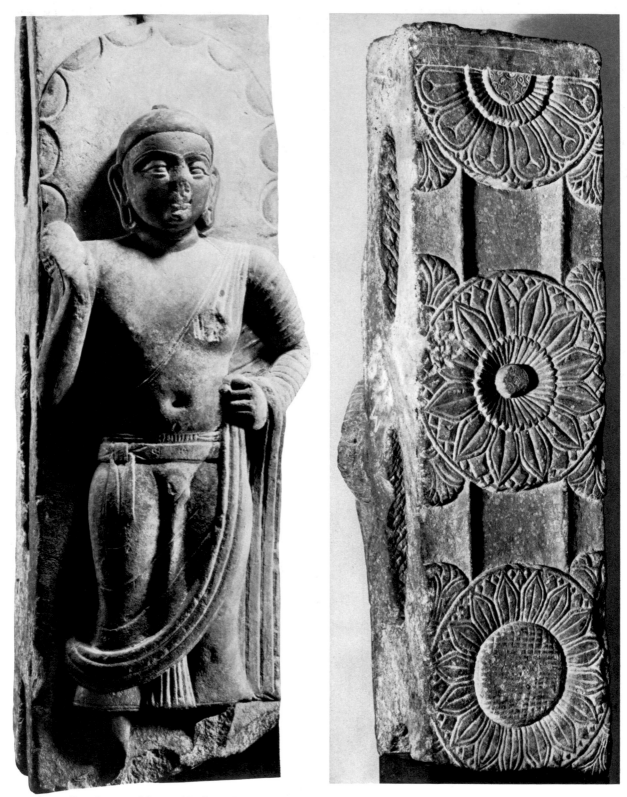

9. Railing Pillar of a Stupa (*front and back*). *India; Kushan period, ca. second century. Red sandstone;* H. 27½ *in.*

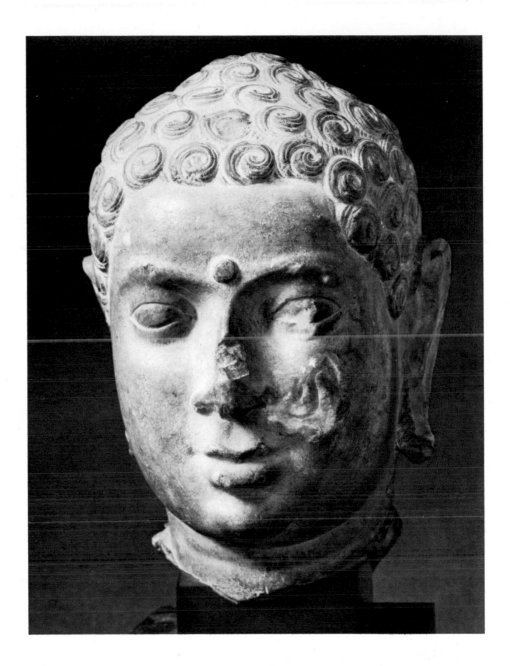

10. Head of Buddha. *India; ca. second century. Marble;* H. *8¼ in.*

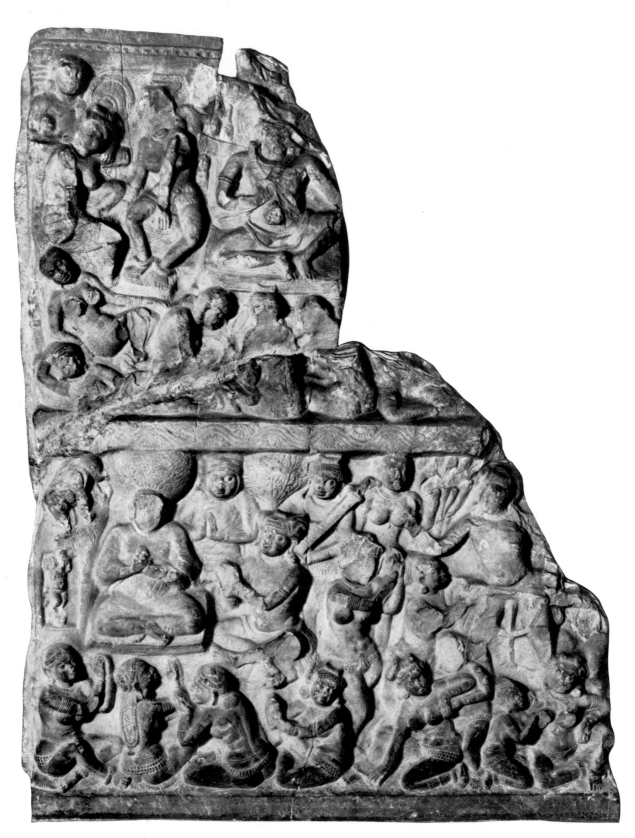

11. Relief Fragment. *India; ca. third century. Marmorean limestone;* H. 51¼ *in.*

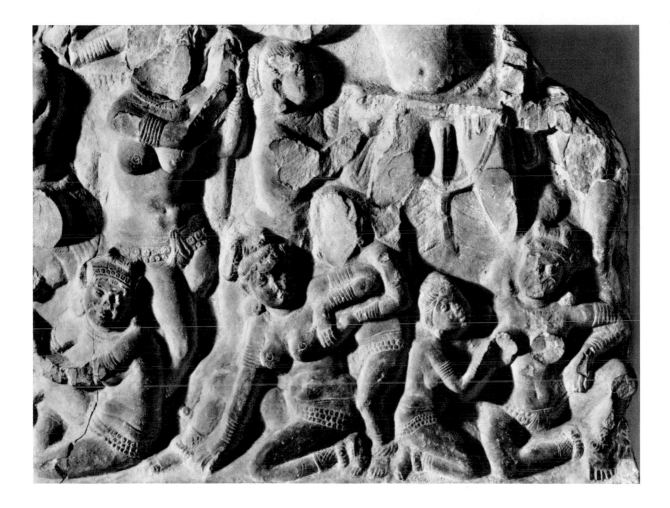

11. *Detail*

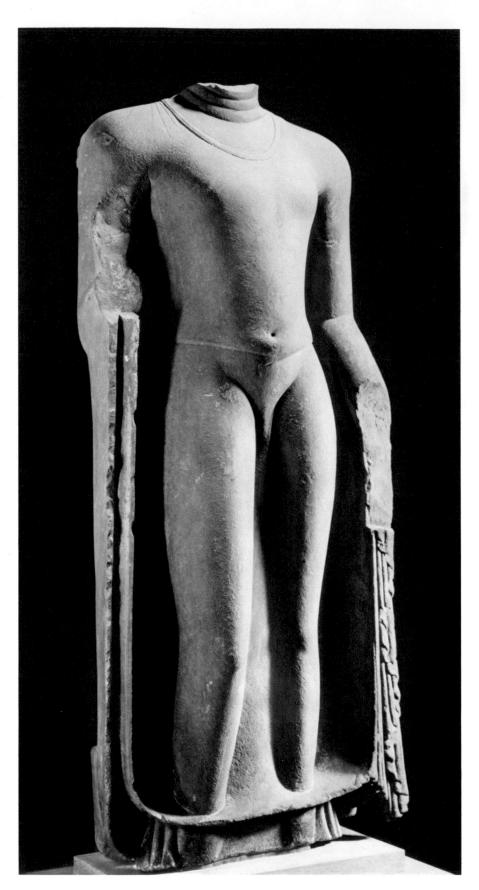

12. Standing Buddha
India; fifth century
Chunar sandstone; H. 38½ *in.*

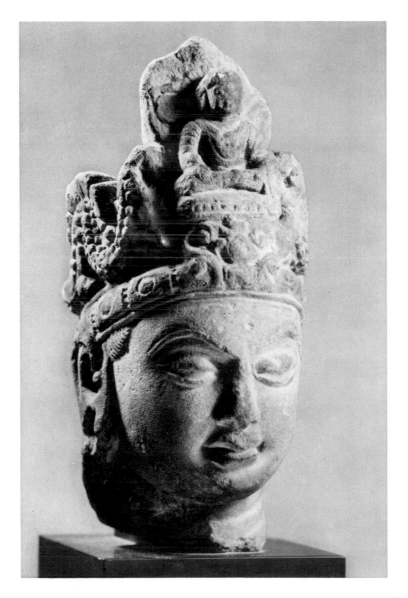

13. Head of Bodhisattva Avalokiteśvara
India; ca. fifth century
Red sandstone; H. *6 in.*

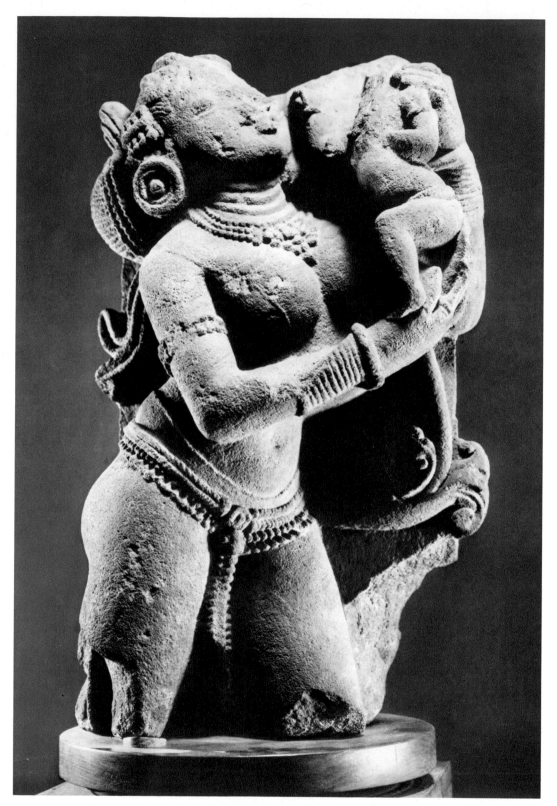

14. Woman Holding a Child. *India; ca. tenth century. Sandstone;* H. 16¼ *in.*

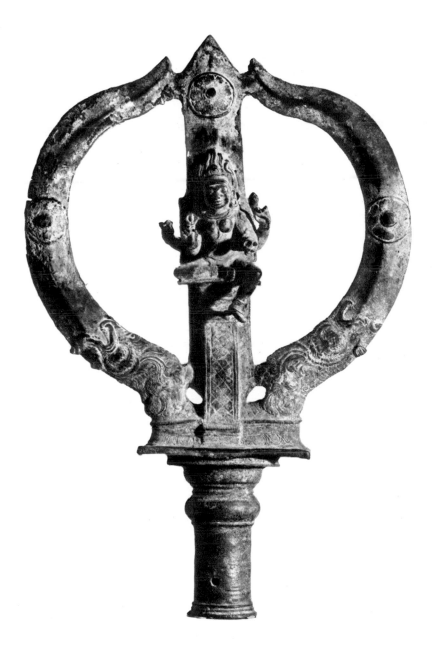

15. Trident (*Triśūla*). *India; Chola period, ca. tenth century. Bronze, with green patina;* H. 21¾ in.

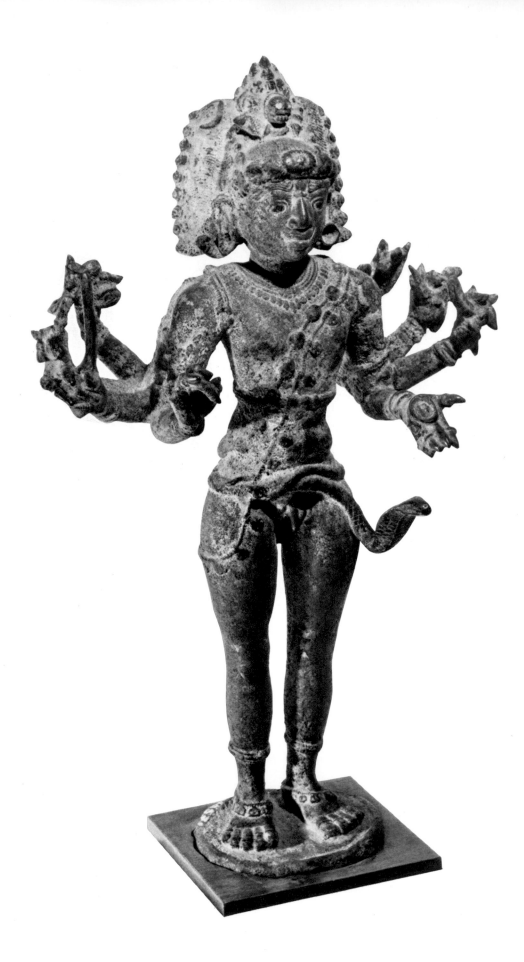

16. Śiva Aghoramūrti
India; Chola period,
tenth–eleventh century
Bronze, with green patina; H. 16¼ *in.*

44

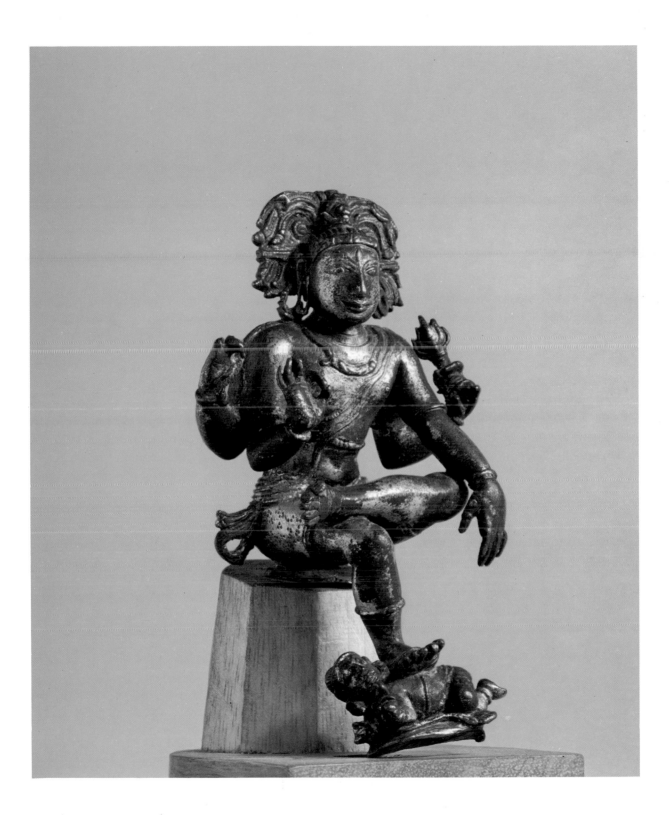

17. Śiva Jñānadakṣiṇamūrti. *India; Vijayanagar period, sixteenth century. Gilt bronze;* H. 4¼ in.

Southeast Asia: Khmer, Champa, Thai and Indonesian Sculpture

THE present Khmer collection of the Musée Guimet is composed mainly of two important groups of sculptures, both of which were assembled during the last years of the ninteenth century—the original collection of the Musée Guimet and that of the old Musée Indochinois du Trocadéro (MIT). The two collections were combined and reorganized at the Musée Guimet between 1927 and 1931. Before this reorganization, the Guimet already possessed, as early as 1880, two statues and two heads. In 1890, its collection was considerably enriched by the sculptures that Etienne Aymonier had brought back from his three expeditions to Cambodia (1882–85); these were deposited at first with the Musée d'Ethnographie du Trocadéro (MET). One of the most famous pieces from the Aymonier Collection is the Harihara of Asram Maha Rosei (see No. 19). All of the 119 pieces then in the museum's possession were catalogued by George Coedès in 1910.

The Khmer collection of the Musée Indochinois du Trocadéro, installed originally at the Palais de Compiègne (MC), contained pieces acquired by Louis Delaporte during his two expeditions to Cambodia (1873–74, 1881–82), for example, the heads found at Phnom Bok and the head from a balustrade in the style of Angkor Wat (see No. 24). These 162 sculptures were also catalogued by George Coedès in 1910.

Apart from other acquisitions and gifts, the Khmer collection was principally enriched by works of art sent home by the Ecole Française d'Extrême-Orient (1931, 1936). The collection of Cham art has come, for the most part, from excavations of the EFEO (1927–28). The Thai collection is largely the result of the Fournereau expedition of 1891 and of the Delaporte expedition of 1882–83. This collection was also enriched by important gifts and by exchanges with the Thai government. Finally, the major portion of the Indo-Javanese bronzes comes from a single magnificent donation (J. J. Meijer, 1922).

We regret that we cannot, in this brief introduction to a limited selection of objects, name all the generous donors to whom this department of the museum, up to this very day, owes its enrichment.

Albert le Bonheur

The following abbreviations have been used in this section:

BCAI *Bulletin de la Commission Archéologique de l'Indochine;*
BEFEO *Bulletin de l'Ecole Française d'Extrême-Orient;*
Inv. inventory number in E. Lunet de Lajonquière's *Inventaire descriptif des monuments du Cambodge.*

18 STANDING BUDDHA MG 18891
Cambodia; Khmer, pre-Angkor period
Sandstone; H. 37⅜ in. (95 cm.)

The forearms of this frontally oriented statue are raised symmetrically. The right hand makes the gesture of teaching (*vitarkamudrā*), which may also have been the mudrā of the left hand. The hair is dressed in broad flat curls; the *ushnisha* on the top of the head is not very prominent. These characteristics, as well as the pose and the costume, relate this image to the Buddhist art of the Mon empire of Dvāravatī, which was contemporaneous with Khmer art. The clothing (a *uttarāsanga* over an *antaravāsaka*) appears transparent and conveys the luminosity of the Buddha's body. The asexual appearance, resulting from the practice of Yoga, is one of the distinctive marks (*lakṣaṇa*) of the Buddha in Southeast Asian art. The octagonal pedestal once must have been set in a circular pedestal in the shape of a full-blown lotus (*padmapīṭha*).

On the back of the image is inscribed the Buddhist creed, here written in "hybrid" Pāli: "Things (*dharma*) that are produced by a cause. He has told this cause, and their ceasing. He spoke thus, the Great Ascetic." According to Jean Boisselier, the statue probably dates from near the end of the seventh century, judging from the manner in which the flap of the *uttarāsanga* is folded around the left wrist. The connections with Dvāravatī art are further confirmed by the Hīnayāna Buddhist character of the inscription.[1]

The head and right arm have been reattached to the figure. The tips of the fingers of the right hand and the entire left hand are missing.　　　(A.L.B.)

From Tûol Preah Theat; sent to the Guimet in 1936 by the Direction des Arts Cambodgiens.

Published: R. Dalet, "Quelques nouvelles sculptures khmères," *BEFEO*, vol. XXXV (1935), pls. XXXIIa and b, pp. 156, 157; P. Dupont, *La Statuaire préangkorienne* (Ascona, Switzerland, 1955), pls. XLV b and XLVI c, p. 190 ff; J. Boisselier, *La Statuaire khmère et son évolution* (Saigon: EFEO, 1955), pl. 88 b, pp. 86, 88; J. Boisselier, *Le Cambodge* (*Manuel d'archéologie d'Extrême-Orient*, pt. I: *Asie du Sud-Est*), vol. I (Paris, 1966), p. 270; O. Monod, *Le Musée Guimet* (Paris, 1966), fig. 47, p. 127.

1. See G. Coedès, *Inscriptions du Cambodge* (Hanoi and Paris, 1937–66), vol. VII, p. 108; and K. Bhattacharya, *Les Religions brahmaniques dans l'ancien Cambodge, d'après l'épigraphie et l'iconographie* (Paris: EFEO, 1961), p. 17.

19 HARIHARA WITH FOUR ARMS MG 14910
Cambodia; Khmer, pre-Angkor period
Polished sandstone; H. 69 in. (175 cm.)

This is a syncretic deity (but Śivaite, nevertheless), born of the union of Hari, or Viṣṇu (left half of the figure), and of Hara, or Śiva (right half, the more noble part). Śiva's hair is dressed in a cylindrical chignon with the braided locks of an ascetic (*jaṭāmukuṭa*) in front of which appears the crescent moon. On the forehead can be seen the third (half) eye, placed in a vertical position. The figure is clothed in a tiger's skin, the head and paws of which are easily discernible. In the lower of its two hands, both now missing, this half of the god held a trident, the top of which remains. Viṣṇu, to the left, may be recognized by his high cylindrical miter and by the disk (*cakra*) still held in his upper hand. He is clothed in a *sampot* with concentric folds and a long central flap.

The fragile parts (the hands and attributes) of this sculpture in the round are strengthened by an arch of stone that holds them to the body. The arch frames the image, giving it additional support. The thickness of the neck serves the same function. The earlobes are pierced, but the precious earrings the figure once wore have disappeared. The face has been gilded relatively recently. The figure has a remarkable sense of unity in spite of its asymmetry. Pierre Dupont has identified the style of this sculpture as Phnom Dà, group A, which he dates from the first half of the sixth century. However, unpublished works (J. Boisselier) tend to place this group as much as two centuries later.

The head and left arms have been reattached to the body. The entire upper right arm, the lower right forearm, the lower left hand, the feet, the handle of the trident, and part of the supporting arch are missing.
(A.L.B.)

Found near the incompleted sanctuary of Asram Maha Rosei (Inv. 19). Sent to France by the Aymonier Expedition, 1882–83; MET, 1886(?); MG, 1890.

Published: E. Aymonier, *Le Cambodge*, vol. I (Paris, 1900), pp. 199, 200; E. Lunet de Lajonquière, *Inventaire descriptif des monuments du Cambodge*, vol. I (Paris: EFEO, 1902), fig. 54, p. 14; G. Coedès, "Catalogue des pièces originales de sculpture khmère conservées au Musée Indochinois du Trocadéro et au Musée Guimet," *BCAI*, vol. XII (1910), p. 31 (no. G.3); V. Goloubew, "Le Harihara de Maha Rosei," *Etudes asiatiques EFEO*, vol. I (1925), pp. 285–95; H. Parmentier, *L'Art khmer*

primitif (Paris: EFEO, 1927), vol. I, fig. 110, p. 245; P. Dupont, *Musée Guimet: Catalogue des collections indochinoises* (Paris, 1934), p. 62; Dupont, *La Statuaire préangkorienne*, pl. II, p. 25, and pp. 31–42; Boisselier, *La Statuaire khmère*, pl. 7, pp. 25, 98, 99, 208, 227, 229, 252; Boisselier, *Manuel d'archéologie*, p. 235; Monod, *Le Musée Guimet*, fig. 45, p. 125; *Gimē Tōyō Bijutsukan* (Tokyo: Kodansha, 1968), pl. 17.

20 STANDING FEMALE FIGURE MG 18094
Cambodia; Khmer, pre-Angkor period
Sandstone; H. 57 in. (145 cm.)

The figure, its hips slightly swayed to the right, is in the *ābhaṅga* posture. The hair is piled high in the arrangement called *jaṭāmukuṭa*.[1] The earlobes are pierced. There are "beauty folds" in the neck. The skirt, which widens slightly at the bottom, is held in place by a belt with the engraved representation of a jeweled buckle; it has gathered drapery, concentric pleats, and a long center flap. The *jaṭāmukuṭa* leads one to believe (according to certain epigraphic indications) that this image represents, along with other similar ones of the pre-Angkor period, the wife of Śiva, who is called simply Devī, or the Goddess, in the Khmer texts (J. Boisselier). There is a general impression of restraint in the modest pose, the veiled forms, and the discreet modeling.

The statue is thought to be from a later period than that of Sambor Prei Kuk because of the way the *jaṭā-mukuṭa* is treated and the incised lines that define the costume; the composition of the hairstyle suggests a relationship with certain bronzes of the Prakon Chai group (eighth century?). The head and right arm have been reattached. The forearms and the feet are missing. (A.L.B.)

From the island of Koh Krieng (Inv. 140). Gift of Adhémar Leclère. MIT, 1896; MG, 1927.

Published: Lunet de Lajonquière, *Inventaire descriptif*, p. 192; Coedès, "Catalogue des pièces originales," pl. II, p. 9 (no. T.14); Parmentier, *L'Art khmer primitif*, vol. I, fig. 103 and pp. 213, 245, 302, 321; Dupont, *Musée Guimet*, p. 60 (1–3); Dupont, *La Statuaire préangkorienne*, pls. XXXII a and b, pp. 116, 180, 181, 184; Boisselier, *La Statuaire khmère*, pl. 24 b, pp. 102, 167, 211, 230; Boisselier, *Manuel d'archéologie*, pp. 242, 294; Monod, *Le Musée Guimet*, fig. 6, p. 125.

1. See R. Regnier, "Note sur l'évolution du chignon (*jaṭā*) dans la statuaire préangkorienne," *Arts asiatiques*, vol. XIV (1966), pp. 22, 23; J. Boisselier, "Notes sur l'art du bronze dans l'ancien Cambodge," *Artibus Asiae*, vol. XXIX, no. 4 (1967), p. 306; A. le Bonheur, "Un Bronze d'époque préangkorienne représentant Maitreya," *Arts asiatiques*, vol. XXV (1972), pp. 142, 144–46.

21 TORSO OF VIṢṆU MG 18861
Cambodia; Khmer; middle or late third quarter of the ninth century
Sandstone; H. (remaining fragment) 35½ in. (90 cm.)

The torso is leaning noticeably on one hip; the four arms (Viṣṇu Caturbhuja) are broken off. There are "beauty folds" on the neck. The modeling is very beautiful, but the forms are slightly blurred and somewhat fleshy looking. The costume combines a naturalistic treatment with a decorative stylization.

The sculpture is an example of the Kulên style and comes from Pràsàt Thmà Dap (Inv. 557.2). It directly foreshadows the Preah Kô style. (A.L.B.)

Sent to France in 1936 by the EFEO.

Published: P. Dupont, "L'Art du Kulên et les débuts de la statuaire angkorienne," *BEFEO*, vol. XXXVI (1936), p. 415 ff.; Ph. Stern, "Le Style de Kulên," *BEFEO*, vol. XXXVIII (1938), p. 111 ff.; Boisselier, *La Statuaire khmère*, pl. 5, fig. 2, pp. 32, 34, 169, 170, 212, 232, 233; Boisselier, *Manuel d'archéologie*, pl. XXXIII, no. 2, p. 244; Monod, *Le Musée Guimet*, fig. 48, p. 128; *Gimē Tōyō Bijutsukan*, pl. 18.

22 HEAD OF BRAHMA MG 18100
CATURMUKHA
Cambodia; Khmer
Polished sandstone; H. 20½ in. (52 cm.)

The four heads of this monumental fragment are joined only at the back, the ears remaining free. Here the *jaṭāmukuṭa*, hairstyle of the ascetics, has become a strictly cylindrical mass, as opposed to the naturalistic treatment of the pre-Angkor period (see No. 20). The heads wear diadems; the ears are pierced. The rigorously geometric stylization, polished metal-like surface, and sharp-edged line of the eyebrows impart a hieratic quality and a certain severity to the sculpture. These are characteristics of the Bàkheng style (after 893; ca. 925), which corresponds to the reign of Yasovarman, the founder of the first city of Angkor. This piece was found by Louis Delaporte in Phnom Bok

(Inv. 547) but in one of the annexes, along with a head of Śiva and a head of Viṣṇu in the same style which are also preserved in the Musée Guimet (MG 18101 and 18102). (A.L.B.)

Acquired by the Delaporte expedition, 1873–74; MC, 1875; MIT, 1878; MG, 1927.

Published: De Croizier, *L'Art khmer: Etude historique sur les monuments de l'ancien Cambodge* (follows a catalogue raisonné of the Musée Khmer de Compiègne [Paris, 1875]), pp. 98, 112 (no. VII); L. Delaporte, *Voyage au Cambodge: l'Architecture khmer* (Paris, 1880), pp. 126, 341; Coedès, "Catalogue des pièces originales," p. 20 (no. T.87); Dupont, *Musée Guimet*, p. 68 (2–3); Boisselier, *La Statuaire khmère*, pl. 40 b, pp. 109, 172, 177, 214, 215; M. Glaize, *Les Monuments du groupe d'Angkor*, 3rd ed., rev. (Paris, 1963), pp. 267, 268.

23 MALE STATUE WITH HORSE'S MG 18099
HEAD (Form of Viṣṇu)
Cambodia; Khmer
Polished sandstone; H. 53 *in.* (135 *cm.*)

The headdress in the form of a pyramid on an octagonal base is generally attributed in Khmer art of this period to Viṣṇu. According to J. Boisselier, the figure is Viṣṇu Hayagrīva. There is some possibility that it might also represent the Kalkyavatāra, since the human body/animal head form is found ascribed to Kalkī in texts and representations of South India. The horse's head, which displays a bold geometric stylization, is convincingly attached to a human neck. The diadem and costume are later—in their treatment, modifications, and enrichments—than those that are characteristic of the style of Bàkheng. On the other hand, the proportions of the body (torso "like an hour-glass") and the polished surface are again those of the Bàkheng style.

The figure is in the official, archaistic style of Prè Rup (947–ca. 965), corresponding to the reign of Rajendravarman and the return of the capital to Angkor, thus later by fifty years than the Bàkheng style and also later than the style defined by the ephemeral capital of Koh Ker. Part of the diadem and the right arm have been reattached. The right forearm, left arm, and the legs below the knees are missing.

Found in Sambor Prei Kuk. According to Lunet de Lajonquière, who based his opinion on a letter from Adhémar Leclère, the statue comes from building

no. 7, but this location is very doubtful (H. Parmentier). (A.L.B.)

Gift of Adhémar Leclère; MIT, 1896; MG, 1927.

Published: Aymonier, *Le Cambodge*, vol. I, p. 372; Lunet de Lajonquière, *Inventaire descriptif*, fig. 47, pp. xcvii, 233; Coedès, "Catalogue des pièces originales," p. 9 (no. T.15); Parmentier, *L'Art khmer primitif*, vol. I, pp. 66, 67, 245; Dupont, *Musée Guimet*, pp. 66, 67 (2–3); Boisselier, *La Statuaire khmère*, pp. 40, 236; Boisselier, *Manuel d'archéologie*, pl. XXXVI, p. 249.

24 END OF A BALUSTRADE IN THE MG 18106
SHAPE OF A SEVEN-HEADED NĀGA
Cambodia; Khmer
Sandstone; H. 41 *in.* (104 *cm.*)

The serpents' heads are raised in a very beautiful arch; the ogive that encompasses the stylized flames or clouds of the nimbus is also very elegant. This piece is characteristic of the style of Angkor Wat (first three-quarters of the twelfth century). Its exact origin is unknown (for stylistic reasons, P. Dupont's thesis that it comes from the Royal Terrace cannot be sustained). One serpent's head and some fragments of the other heads and of the nimbus are missing. (A.L.B.)

Acquired by the Delaporte expedition, 1873–74; MC, 1875; MIT, 1878; MG, 1927.

Published: Coedès, "Catalogue des pièces originales," p. 24 (no. T.123); Dupont, *Musée Guimet*, p. 96 (3–41); Monod, *Le Musée Guimet*, fig. 62, p. 144.

25 MALE HEAD P 430
Cambodia; Khmer, ca. 1181–1218
Sandstone, with traces of gilding;
H. 15¾ *in.* (40 *cm.*)

This head is presumably a portrait of King Jayavarman VII, who restored and rebuilt Angkor in the late twelfth century. The face is energetic looking in spite of a certain fleshy quality in the lower part. The mouth is large and smiling, the eyes are closed, and there is an over-all meditative expression. The smooth hair is fastened at the top of the skull in a little hemispheric chignon. The earlobes are pierced and distended but without jewels. There is no trace of idealization. This major work, in the Bayon style, is one of the four

known effigies—two heads and two whole statues—of King Jayavarman VII executed during his lifetime (G. Coedès). (A.L.B.)

Placed in the Musée Guimet by the Faculté des Sciences de Marseille. Gift of Commander Coreil.

Published: A. Foucher, "Matériaux pour servir à l'étude de l'art khmer," *BCAI* (1912), p. 218; G. Coedès, "Le Portrait dans l'art khmer," *Arts asiatiques*, vol. VII, no. 3 (1960), pp. 179–98; Monod, *Le Musée Guimet*, p. 161; *Gime Tōyō Bijutsukan*, pl. 23.

26 FRAGMENT OF A DEMONIC HEAD MA 24
Cambodia; Khmer, ca. 1200
Sandstone; H. 23¼ in. (59 cm.),
 W. 17 in. (43 cm.)

The frowning eyebrows, popping, round eyes, and grimace indicate the head's demonic aspect. It more than likely came from a "Giant's Way" (an axial road crossing the moats), one of the three groups of the Bayon style: the road of Angkor Thom (the most probable), or of Preah Khan of Angkor, or Banteay Chmar. These "giants" are placed in long lines along the sides of the roads; on one side are the friendly types, on the other, the demonic. Each line holds the body of a long serpent, and the groups represent the rainbow that leads from the world of men to the city of the gods (with a passing allusion, but nothing more, to the story of the "Churning of the Sea of Milk"). (A.L.B.)

Purchased in 1943.

Published: *L'Amour de l'art*, no. 5 (October 1945); Monod, *Le Musée Guimet*, fig. 82, p. 170.

27 TWO FRAGMENTS OF ARCHITECTURAL DECORATION MG 18055, 18056
Champa; tenth century
Pink sandstone; H. (a) 22¾ in. (58 cm.),
 (b) 23¼ in. (59 cm.)

The very beautiful and naturalistic treatment of the two elephants, which convey a sense of suppleness and volume, is characteristic of tenth-century Cham art. They are in the style of Mi Son A1. No. 27a has lost the tusks and the upper part of the trunk; No. 27b,

the tusks, back feet, and tip of the tail. *Cf.* J. Boisselier, *La Statuaire de Champa: Recherches sur les cultes et l'iconographie* (Paris: EFEO, 1963), figs. 127, 128, pp. 200, 201. (A.L.B.)

From Tra-kieu, from the finds of the EFEO expedition, 1927–28. Sent to the Musée Guimet in 1931.

Published: *BEFEO*, vol. XXVII (1927), p. 468 ff.; *BEFEO*, vol. XXVIII (1928), p. 378 ff.; *BEFEO*, vol. XXX (1930), pp. 184, 210, 489; *BEFEO*, vol. XXXI (1931), p. 645 (nos. 18, 19); Dupont, *Musée Guimet*, pp. 141, 142 (6–1 and 6–2); Monod, *Le Musée Guimet*, figs. 87, 88, p. 178.

28 HEAD OF BUDDHA MA 2688
Thailand; fourteenth century
Bronze; H. 11 in. (28 cm.)

In the very delicately modeled face, one may note the stylized treatment of the edge of the mouth and of the eyes, which are elongated toward the temples. The hair, arranged in tiny bosses of curls, is decorated with a fillet along the forehead. The *ushnisha* is topped by a pointed flame that seems to be made up of forms borrowed from the vegetable kingdom. In the style of U Tong, Group B. (A.L.B.)

Gift of Mlle. Edith de Gasparin, 1965.

Published: *Arts asiatiques*, vol. XII (1965), pp. 185, 186; Monod, *Le Musée Guimet*, p. 201.

29 TEN-ARMED BODHISATTVA LOKEŚVARA MG 3816
Central Java; ca. ninth century
Bronze, with light green patina;
 H. 13½ in. (34 cm.)

Placed in front of the Bodhisattva's chignon (*jaṭāmukuṭa*) is a representation of Jina Amitābha. The attributes held in Lokeśvara's hands, and the gestures (*mudrā*), may be identified as follows: from top to bottom, right hands—rosary, snare (broken), gesture of giving (*varamudrā*), ewer, gesture of exposition or teaching (*vitarkamudrā*); left hands—book, elephant hook or "triple staff" (the sort of symmetrical logic often observed in images with multiple arms would suggest that opposite the noose or snare in the right hand, one would find a weapon in the left hand), ges-

ture of absence of fear (*abhayamudrā*), stem and bud of pink lotus, gesture of exposition. Behind the head is a flaming nimbus. Around the loins, falling over the garment, is a tiger's skin, a sign of the influence of Śivaite iconography on that of Mahāyāna Buddhism, which was stronger in Indonesia than elsewhere (*cf.* No. 19). Jewelry bedecks the figure. This bronze is one of the major pieces in the collection of the Musée Guimet and one of the most beautiful of all those now known. The modeling, proportions, and balance of the composition are all admirable. (A.L.B.)

Gift of J. J. Meijer, 1922.

Published: N. J. Krom, in *Nederland India Oud en Nieuw*, January 1917, fig. 16, p. 394; A. J. Bernet Kempers, *Ancient Indonesian Art* (Amsterdam and Cambridge, Mass., 1959), pl. 34; Monod, *Le Musée Guimet*, fig. 111, p. 218; A. le Bonheur, *La Sculpture indonésienne au Musée Guimet: Catalogue et étude iconographique* (Paris, 1971), pp. 157–61.

30 JAMBHALA MG 3814
Central Java; ca. ninth century
Bronze, with dark green patina;
H. 11 *in.* (28 *cm.*) ill. p. 10

Jambhala, the Buddhist divinity of wealth, adapted from the Hindu god Kuvera, is represented as young and big-bellied, covered with a profusion of jewels, offering a lemon (*jambhara*) in the right hand, and in his left hand holding by the neck a mongoose (*nakula*) which spits forth a garland of jewels. He is seated in the posture of "royal ease" (*lalitāsana*), the right foot resting on an inverted vase, which is also spilling jewels. Before the projecting section of the pedestal there are seven other receptacles: these may stand for the Eight Treasures (*aṣṭanidhi*) or the money bags which are the usual attribute of the god. The throne with its motif of a lion (solar and royal animal) devouring an elephant (royal mount and symbol of the earth) is appropriate for a universal sovereign and a divinity —especially a divinity as prized as Jambhala seems to have been in ancient Java. On the back of the pedestal is inscribed the Buddhist creed (*cf.* No. 18), but here in Sanskrit and in the so-called pre-Nāgarī (or Siddham) writing of northeast India. Generous modeling, composition perhaps a bit too complete, but great beauty

in the animal motifs of the throne distinguish this bronze. The halo or other backing is missing. (A.L.B.)

Gift of J. J. Meijer, 1922.

Published: Krom, in *Nederland India Oud en Nieuw*, January 1917, figs. 2, 3, p. 391; Bernet Kempers, *Ancient Indonesian Art*, pl. 167; Monod, *Le Musée Guimet*, fig. 112, p. 218; Le Bonheur, *La Sculpture indonésienne*, pp. 182–86.

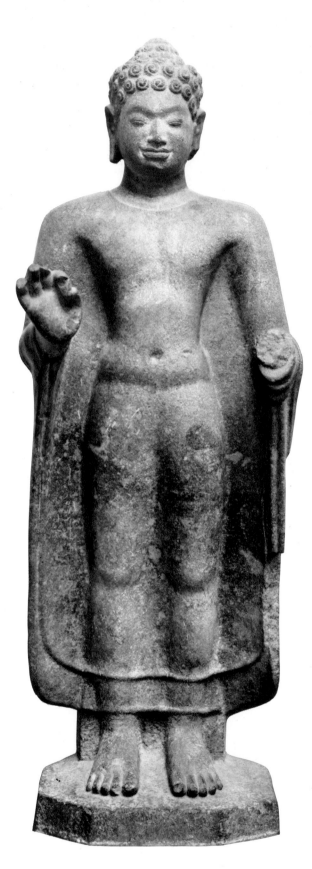

18. Standing Buddha
Cambodia; Khmer, pre-Angkor period
Sandstone; H. 37⅜ *in.*

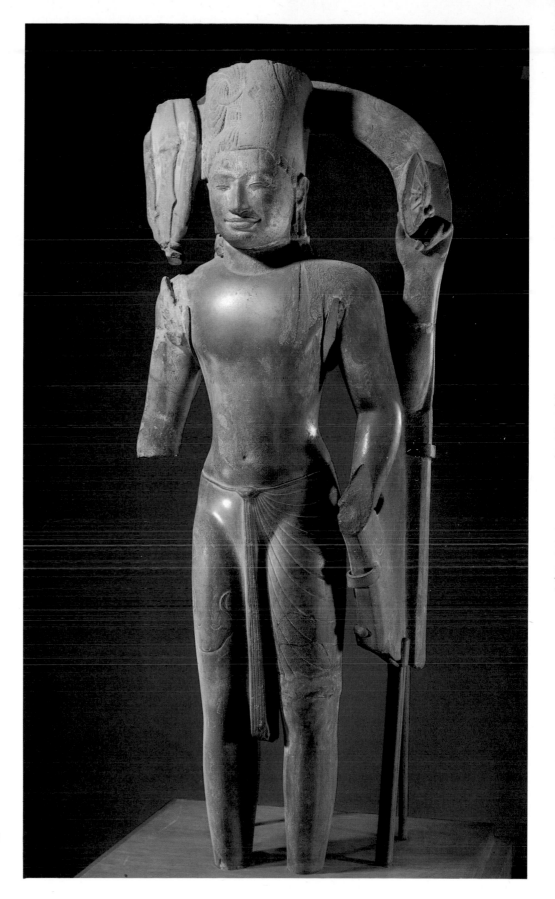

19. Harihara with Four Arms
Cambodia; Khmer, pre-Angkor period
Polished sandstone; H. 69 *in.*

53

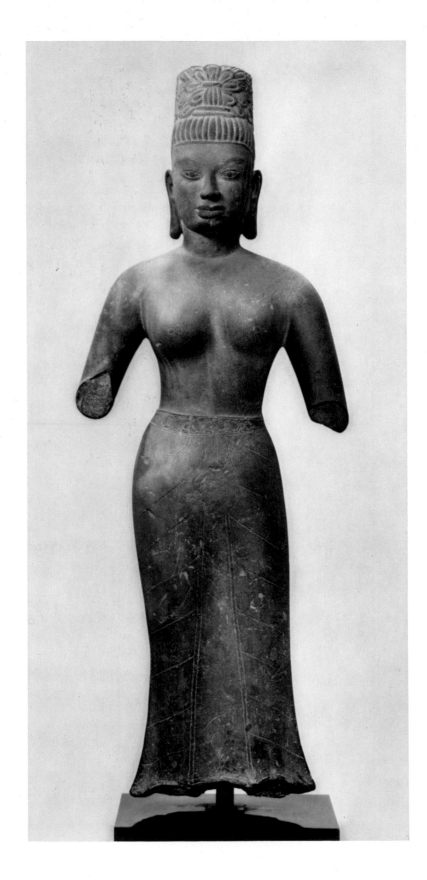

20. Standing Female Figure
Cambodia; Khmer, pre-Angkor period
Sandstone; H. *57 in.*

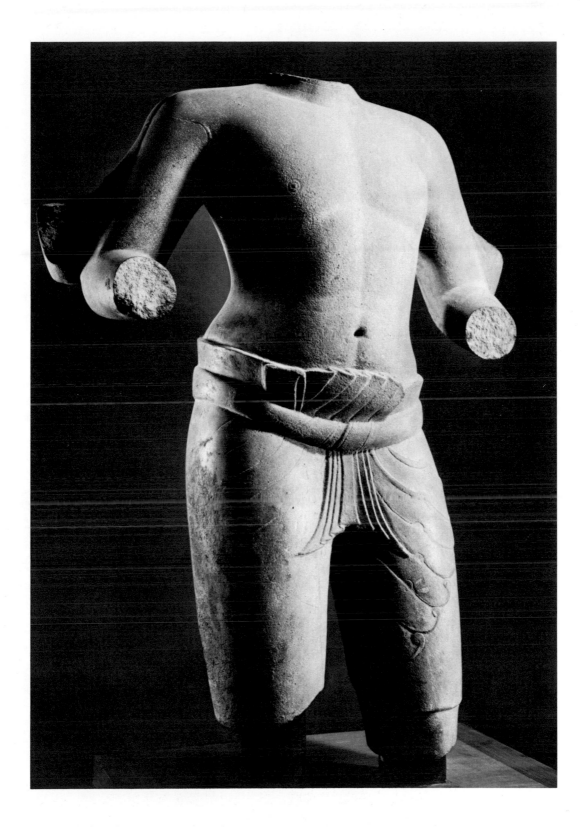

21. Torso of Viṣṇu. *Cambodia; Khmer, ca. 850–75. Sandstone;* H. *35½ in.*

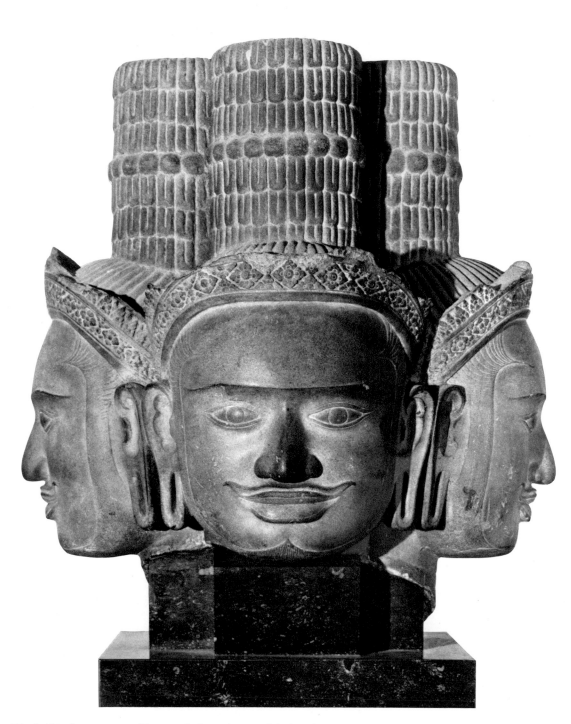

22. Head of Brahma Caturmukha. *Cambodia; Khmer. Polished sandstone;* H. *20½ in.*

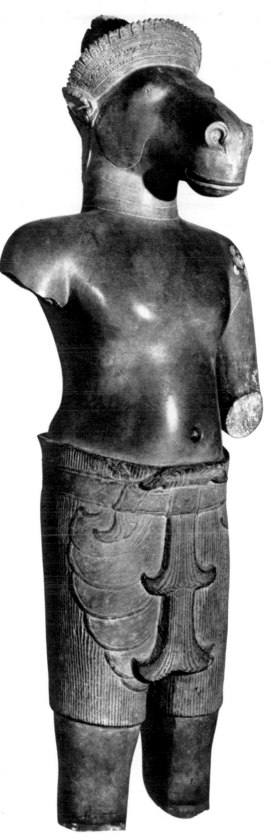

23. Male Statue with Horse's Head (Form of Viṣṇu). *Cambodia; Khmer. Polished sandstone;* H. *53 in.*

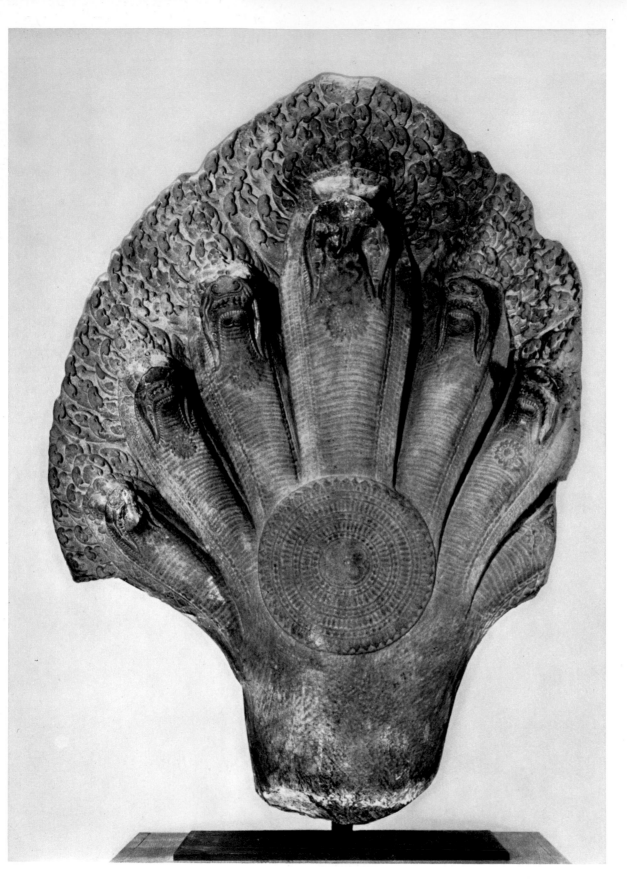

24. End of a Balustrade in the Shape of a Seven-Headed Nāga. *Cambodia; Khmer. Sandstone;* H. 41 *in.*

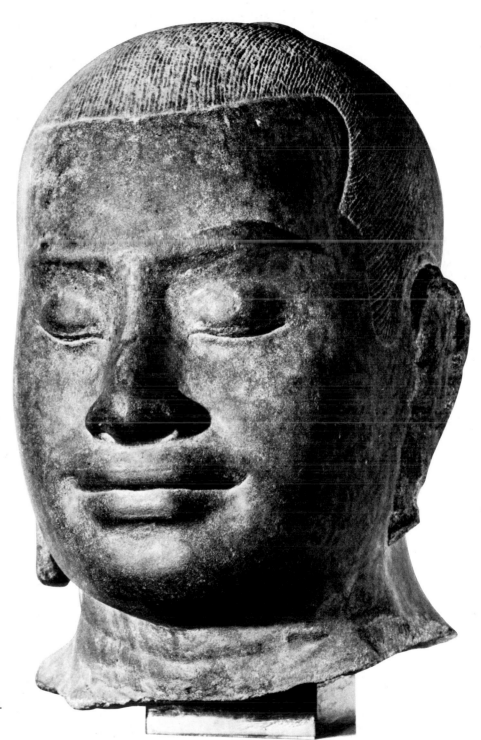

25. Male Head
Cambodia; Khmer, ca. 1181–1218
Sandstone, with traces of gilding; H. 15¾ in.

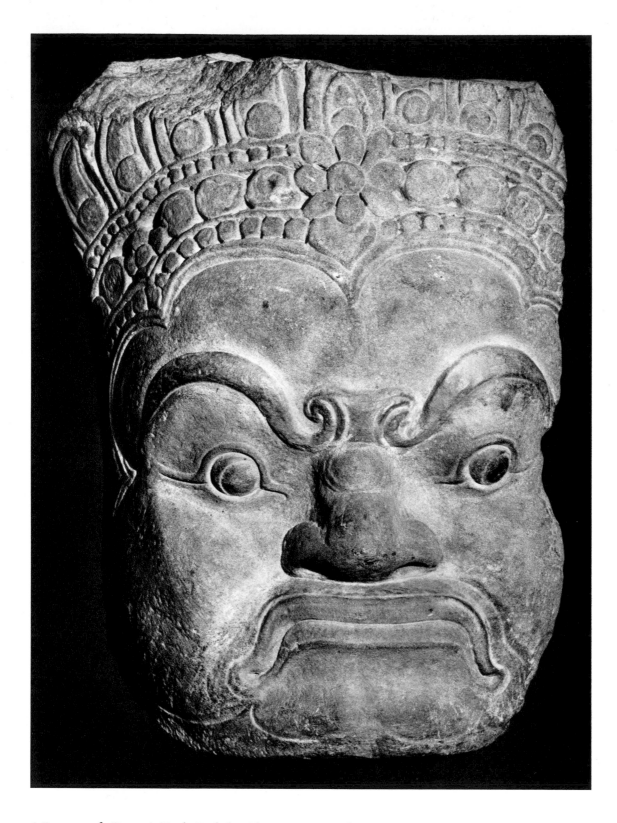

26. Fragment of a Demonic Head. *Cambodia; Khmer, ca.* 1200. *Sandstone;* H. 23¼ *in.*

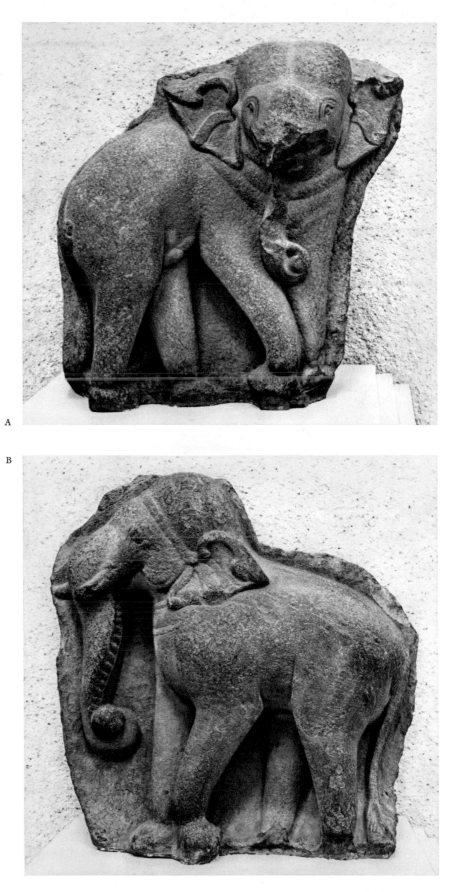

A

B

27. Two Fragments of Architectural Decoration
Champa; tenth century
Pink sandstone; H. (a) 22¾ *in.,* (b) 23¼ *in.*

61

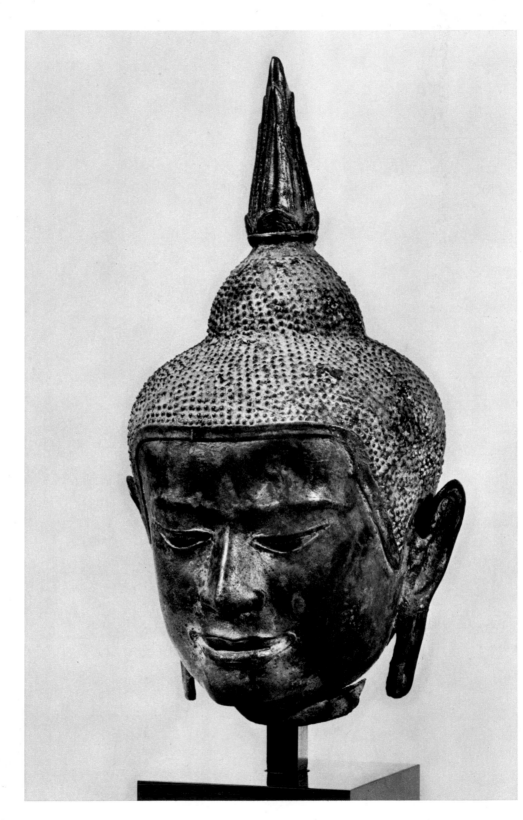

28. Head of Buddha. *Thailand; fourteenth century. Bronze;* H. 11 *in.*

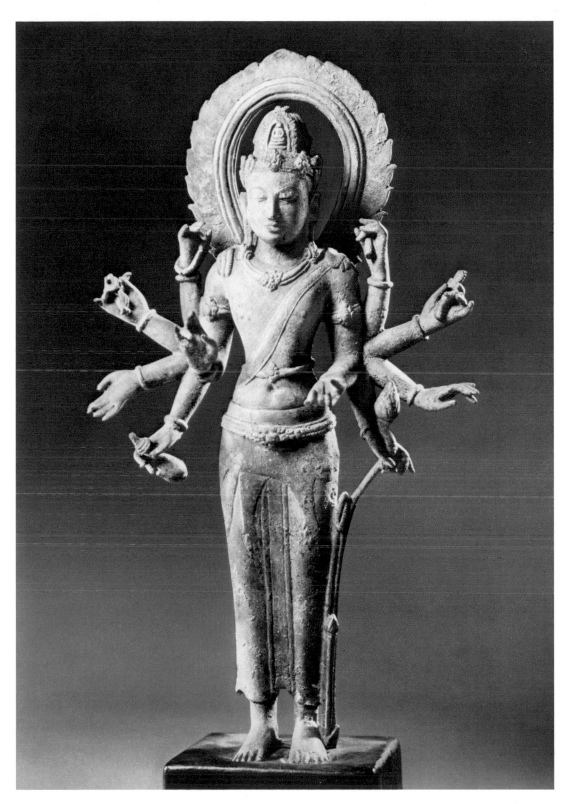

29. Ten-Armed Bodhisattva Lokeśvara. *Central Java; ca. ninth century. Bronze, with light green patina;* H. 13½ *in.*

Nepal and Tibet: Paintings and Sculpture

NEPAL

UNTIL recently, the Musée Guimet possessed only a small number of objects from Nepal, all of very high quality. Several years ago the American public was able to enjoy one of these, the large scroll of the "Legend of Banasura," which was displayed in New York in the exhibition *The Art of Nepal* (Asia House, 1964), no. 103.

In 1955, the Institute de France had the honor of presenting to the Musée Guimet the group of Nepalese paintings assembled by the Englishman B. H. Hodgson (1800–1894) during his stay in the Kathmandu Valley from 1824 to 1843 (see A. Foucher, *Catalogue des peintures népalaises et tibétaines de la collection B. H. Hodgson*, Paris, 1897). The collection has also been supplemented by systematic purchases. Thus, by examining several large wood sculptures, one may now follow, in Paris, the evolution of Newari sculpture from the fifteenth to the beginning of the nineteenth century. Recently a special effort has been made to bring together, despite their rarity, a coherent group of ancient bronzes.

Gilles Béguin

31 THE BUDDHA VAJRADHARA MG 22800
AND HIS PRAJÑĀ VAJRADHĀTVIŚVARĪ
Paṭa, dated Nepal-Samvat 608 (A.D. 1488)
Painting on canvas; H. 39⅜ *in.* (100 *cm.*),
W. 29½ *in.* (75 *cm.*)

Next to Vajradhara, seated in *dhyanāsana*, forming the sign of *prajñālinganābhinaya*, the hands in *vajrahuṁkāra-mudrā*, is placed his prajñā Vajradhātviśvarī. Among the seven deities portrayed at the upper edge of the painting, one finds the five Jina (Dhyāni Buddhas). In the center of the composition, in the middle of the left corner, is Acala (or Caṇḍarosana) between two smaller figures, Arapacana Mañjuśrī and Ṣaḍakṣara Avaloki-teśvara; on the opposite side is a blue Mahākāla, between Avalokiteśvara and Vasudhārā. Along the bottom edge of the painting are scenes depicting danc-ing figures and a consecration ceremony in which an offering is carried into the fire (*homa*). The second panel on the left is devoted to the blue Mahākāla.

Beneath this frieze is an inscription bearing the date of Nepal-Samvat 608 (A.D. 1488) and the name of King Jayaratna malla deva. This king, the second son of Yakṣamalla (1428–82) and the unifier of Nepal, is also mentioned on a maṇḍala in the British Museum dated N.S. 624 (A.D. 1504).[1] He appears to have reigned over the kingdom of Kathmandu from 1482 to 1516/20.[2] Of a violent and energetic character, he had the twelve feudal Thakuri massacred and in 1484/85 regained the city of Kathmandu, which had con-tested his royal authority.[3]

This painting takes its place among the rare dated ancient paṭa from Nepal. It is similar in many of its elements to a painting from the John Gilmore Ford Collection representing Śiva,[4] particularly in the de-sign of the leaves, which form an arch above the fig-ures, and in the scenes of the lower section. (G.B.)

Published: O. Monod-Bruhl, "Une Peinture népalaise du Musée Guimet," *Arts asiatiques*, vol. VI, no. 4 (1959), pp. 297–310; D. R. Regmi, *Medieval Nepal* (Calcutta, 1966), pt. 2, p. 974; *Gime Tōyō Bijutsukan* (Tokyo: Kodansha, 1968), p. 71.

1. D. Barrett, "The Buddhist Art of Nepal and Tibet," *Oriental Art* (1957), p. 95.

2. D. R. Regmi, *Medieval Nepal* (Calcutta, 1966), pt. 2, p. 33 ff.

3. *Ibid.*

4. P. Pal, *Indo-Asian Art from the John Gilmore Ford Collection* (Baltimore: Walters Art Gallery, 1971), no. 63, p. 47.

32 BODHISATTVA AVALOKITEŚVARA MA 3343
Ca. seventeenth century
Polychromed wood; H. 54 5/16 *in.* (138 *cm.*)

The figure of Amitābha on the diadem allows us to identify this sculpture, in spite of its blue color, as a form of the Bodhisattva Avalokiteśvara. Similar figures must have been used as statues for worship, as is shown by the Amoghapāśa still in situ in the monastery of Haka-bāhā (Ratnākaramahāvihāra) in the city of Patan.

The head, the body, the base, and the upper part of the right arms are carved from a single block of wood. The upper left arms and the forearms were sculpted separately and attached with tenons. The statue was entirely painted in blue.

The style of the Guimet statue is very close to that of the sculptured supports in the white Temple of Matsyendranath at Kathmandu. This resemblance allows us to date the work to approximately the seventeenth century. It may be compared with the more simplified and archaic Amoghapāśa Lokeśvara published in the collection of N. and A. Heeramaneck,[1] which has been tentatively dated to the fourteenth–fifteenth century. (G.B.)

Published: G. Béguin, "Musée Guimet: Quatre statues népalaises," *La Revue du Louvre et des Musées de France* (1973), pp. 387–92.

1. *The Arts of India and Nepal: The Nasli and Alice Heeramaneck Collection* (Boston: Museum of Fine Arts, 1966), no. 96, p. 88.

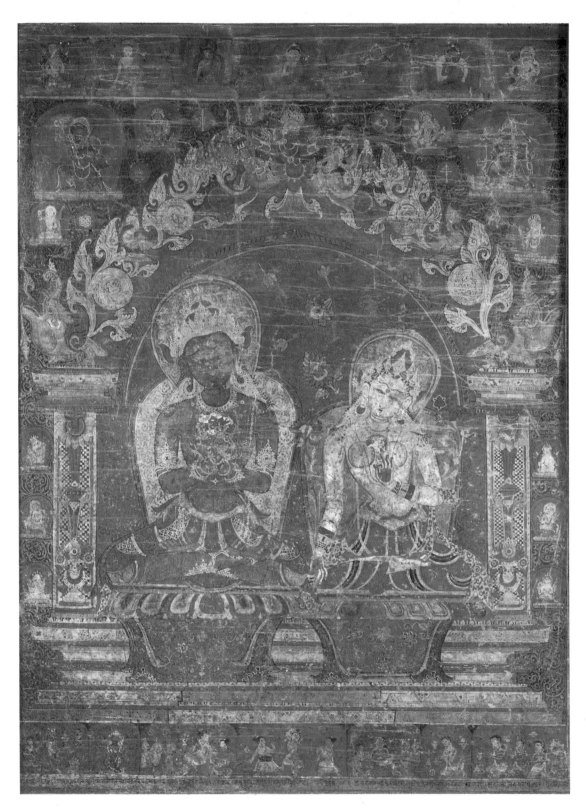

31. The Buddha Vajradhara and His Prajñā Vajradhātviśvarī. *Nepal;* A.D. 1488. *Painting on canvas;* H. 39⅜ *in.*

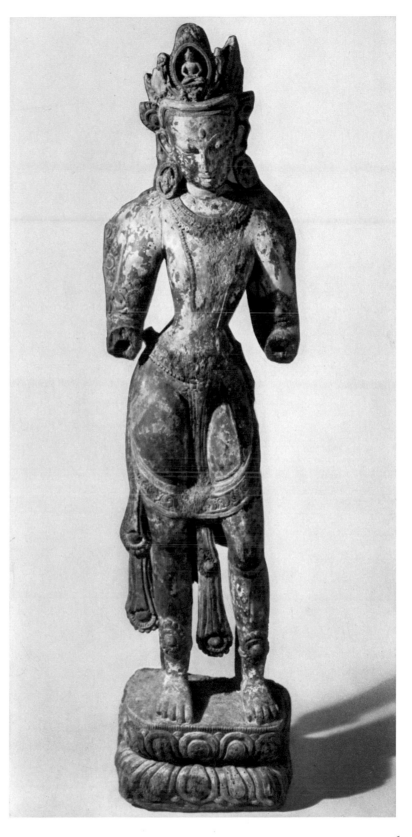

32. Bodhisattva Avalokiteśvara
Nepal; ca. seventeenth century
Polychromed wood; H. 54⁵⁄₁₆ *in.*

TIBET

The Tibetan collection of the Musée Guimet is composed primarily of the group of objects that the famous French Tibetan specialist Jacques Bacot (1877–1965) brought back from his first missions in the Himalayas (1909–10). This group was exhibited at the Guimet in 1911. In 1912 Bacot gave the museum most of his paintings and bronzes; the remainder was acquired in 1952.

The museum's incomparable collection was completed through a policy of purchase systematically followed until recently by Odette Jacques Monod (d. 1972), Curator of the Museum, and by the generosity of many amateurs, principally Dr. Brazier and H. Dublain, Mme. Lepice, C. T. Loo, M. de Marquette, R. Pfister, President G. Toussaint, and still more recently of Philippe Stern, Sir Humphrey Clarke, and Mme. Letamendi.

Certain pieces were brought back by the Citroën expedition in Central Asia (known as "The Yellow Journey," 1931–32). A large portion of the Himalayan objects assembled by two well-known Tibetan experts, Alice Getty and Alexandra David-Neel, are also preserved in the museum.

The Guimet holds about three hundred Tibetan paintings, or thankas. This collection constitutes a group that cannot be equalled, either for its quality or for the variety of styles and iconography it represents. Certain of these, among the most beautiful of the group, are now displayed to the American public.

The collection of statuettes is less brilliant. It presents, however, a rather complete picture of the Lamaist pantheon. The most remarkable piece is, without question, a large dancing Ḍākinī in golden bronze, of human scale (not included here). Several of the museum's bronzes were exhibited at Asia House in New York in 1969 at the time of the exhibition *The Art of Tibet* (nos. 48, 54, 71, and 76). Numerous ritual objects, several pieces of jewelry, and a rich library of block-printed texts complete this group.

The Tibetan collection of the Musée Guimet, famous among art lovers, is actually one of the most beautiful and most complete to be found in Europe.

Gilles Béguin

33 THE BODHISATTVA MG 17477
AVALOKITEŚVARA AND
SAMANTABHADRA
Thanka, first half of eighteenth century (?)
Painting on silk; H. 37¾ in. (96 cm.),
w. 27⅛ in. (69 cm.)

In the center of the picture are placed the Bodhisattvas Avalokiteśvara (in Tibetan, sPyan-Ras-gZigs) and Samantabhadra (in Tibetan, Kun-Tu-bZan-po), who are seated in the *lalitāsana* position on lotus thrones (*padmāsana*). In the upper part of the picture, from left to right, are Nāgārjuna (in Tibetan, Klu-sGrub), the Jina Akṣobhya (in Tibetan, Mi-bsKyod-Pa), and

Asaṅga (in Tibetan, Thog-Med). In the lower part, on the left, is Brāhmanarūpa Mahākāla (in Tibetan, mGon-po-Bram-gZugs) and, in the center, Mahākāla, "protector of the tent" (in Tibetan, Gur-Gyi-mGon-Po). The terrifying female figure in the lower right corner is not identified.

The painting is executed on a gold background (gSer-Than). The style is strongly influenced by Chinese art. The poses and costumes of the two major figures are reminiscent of certain representations of the T'ang and Sung dynasties. The rocks, clouds, and flowers are also taken from Chinese models.

The origin of this work may be eastern or central Tibet. It is reasonable to assume that it is of a later date

than 1720, when the Chinese emissary was established at Lhasa. Nevertheless, it is thought to be much older. (G.B.)

Published: *Gime Tōyō Bijutsukan*, pl. 73.

34 THE YI-DAM HEVAJRA AND HIS PRAJÑĀ NAIRATMYA MG 22848
Thaṅka, ca. eighteenth century
Painting on silk; H. 31⅛ *in.* (79 *cm.*),
 W. 26¾ *in.* (68 *cm.*)

The iconography of this picture follows faithfully the descriptions of Hevajra tantra.[1] In the middle of a flaming circle, Hevajra (in Tibetan, Kye-rDo-rJe) and his prajñā Nairatmya (in Tibetan, bDag-Med-Ma) are entwined (in Sanskrit, *maithuna*; in Tibetan, *yab-yum*), crushing the four Māra. Around Nairatmya, who is represented a second time in the center of the lower part of the picture, are the eight yogini (in Tibetan, *rNal-Byor-Ma*), dancing upon some cadavers and arranged as in a maṇḍala (in Tibetan, *dKyil-Khor*) at the different points of the cosmos.

In the upper part of the picture, placed from left to right, are Vajrasattva (in Tibetan, rDo-rJe-sJems-dPa), a Tantric form of Akṣobhya (in Tibetan, Mi-bsKyod-Pa), according to the Piṇḍikrama; a blue Samvara (in Tibetan, bDe-mChog); then another form of Samvara, with Vajravārāhi (rDo-rJe-Phag-Mo) standing on Bhairava (in Tibetan, Jigs-Byed) and Kālarātī (in Tibetan, gSin-Je-Dus-mChain-Ma); and finally Nadi-Ḍākinī (in Tibetan, Na-ro-mKha-spyo-ma).

The style of this thaṅka is faithful to the Indian examples. A sense of volume is created by the colored concentric rings. This procedure, used at the time of the Indian Pāla dynasty, is found again in Tibet, during the ancient period, in murals as well as on various portable paintings. Some of these were brought back by Professor G. Tucci[2] and others were found in various collections, as for example a Vajrabhairava (in Tibetan, rDo-nJe-Jigs-Byed), from the collection of N. and A. Heeramaneck,[3] or the Raktayamāri (in Tibetan, gSin-sJe-gSed-Mar-Po) of the Boston Museum of Fine Arts.[4]

The Guimet painting does not date from such an early period. The silk mounting indicates perhaps a period of development of Chinese-Tibetan trade, such as the first third of the eighteenth century. (G.B.)

Gift of Miss Densmore, 1939.

1. D. L. Snellgrove, *The Hevajra Tantra* (New York, 1959), 2 vols.
2. G. Tucci, *Tibetan Painted Scrolls* (Rome, 1949), pls. F and G. The Vajrasattva of pl. F is in the Musée Guimet (MA 1089).
3. P. Pal, *The Art of Tibet* (New York, 1969), no. 12.
4. *Lamaist Art*, exhibition catalogue, Boston Museum of Fine Arts (n.d.), no. 36.

35 VIEW OF THE CITY OF LHASA AND THE POTALA MG 21248
Thaṅka, early nineteenth century
Painting on canvas; H. 39 *in.* (99 *cm.*),
 W. 28 *in.* (71 *cm.*)

This painting shows the palace monastery of Potala (Po-ta-La), residence of the Dalai Lama, and the major monuments of Lhasa and of its surroundings. One can recognize, at lower right, the Jo-khan, above the temple of Ra-mo-che. At the left of the Potala is the Ban-sGo-ka-Gliṅ gate. In the upper part, from left to right, are found the three monasteries, pillars of the yellow sect, Bras-sPuṅ, Se-ra, and dGa-lDan. In the lower left part, the artist has added the central sanctuary of the monastery of bSam-Yas, founded around A.D. 779 by Padmasambhava.

It is also possible to see the considerable additions made to the Potala after 1645 by the fifth Dalai Lama, Nag-Dbaṅ-bLo-Bzaṅ-rGya-mCho ("Ocean of Reason"), 1617–82, and finished by the regent Saṅs-rGyas-rGya-mCho ("Ocean of Bodhi") before his death in 1705. All the monuments can be identified by the inscriptions, which are written in Newari.

The Guimet possesses another thaṅka (MA 1043) representing the same subject.[1] There are in existence many such landscapes of the Holy Places of the region of Lhasa. The Musée d'Art et Histoire of Brussels[2] possesses a similar thaṅka, as does a private collection in New York. (G.B.)

Gift of Jacques Bacot, 1912.

1. See O. Monod-Bruhl, *Peintures tibétaines* (Paris, 1954).
2. See *L'Art tibétain*, catalogue from the Exposition Geneva-Zurich (1969), no. 95, p. 94.

33. The Bodhisattva Avalokiteśvara and Samantabhadra
Tibet; first half of eighteenth century (?)
Painting on silk; H. 37¾ *in.*

33. *Detail*

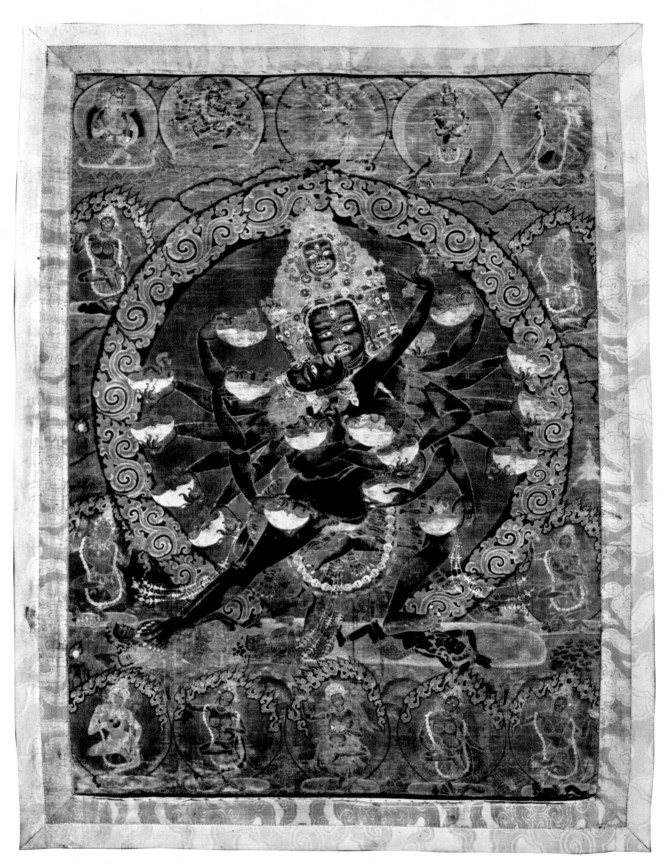

34. The Yi-dam Hevajra and His Prajñā Nairatmya. *Tibet; ca. eighteenth century. Painting on silk;* H. 31⅛ *in.*

35. View of the City of Lhasa and the Potala. *Tibet; early nineteenth century. Painting on canvas;* H. *39 in.*

Ancient Central Asia: Frescoes

Ancient Central Asia encompasses an immense area that extends from the shores of the Caspian Sea to the borders of ancient China. The part that interests us here has been variously designated as Chinese Turkestan or Serindia (eastern Central Asia) and corresponds to the present-day province of Sinkiang in the People's Republic of China. This region is of the utmost importance in the history of the cultural and artistic relations between the great Asian civilizations: the Hellenized Near and Middle East, Iran and India, and finally China. The caravan route that used to cross these immense regions and, to a certain extent, linked Antioch and Alexandria on the shores of the Mediterranean to the capital of China, was, throughout the ages, an extraordinary means of transporting ideas, religions, merchandise—in a word, "civilization."

The Silk Route, as it is called, passed through Mesopotamia, Iran, and Transoxania. It crossed the high hills of Pamir after joining the southern route, which connected it to India. There it divided into two paths: one skirting the chain of the T'ien-shan; the other, more southern one passing the foot of the Kuen-lun mountains. The routes reunited in Tun-huang in western Kansu province, which was the door to the Chinese empire. These trails crossed the desert areas and were marked with oases that became religious and artistic centers.

Toward the end of the nineteenth century, scholars became interested in this part of the world, which was still a blank on the map. This was the origin of the Russian, German, English, Japanese, and French archaeological expeditions. The one that most affected the Musée Guimet was led by Paul Pelliot (1878–1945) between 1906 and 1909; he was accompanied by Dr. Louis Vaillant and the photographer Nouette. They were to follow, under the most difficult conditions, the trails of the Silk Route and gather the archaeological documentation now in the Central Asian and Chinese collections of the museum. The most important sites visited during the course of their travels were Tumsuk, the monasteries of the Kuça region, including Douldour-âqour, and Tun-huang.

Occupied during antiquity by people speaking Indo-European languages, eastern Central Asia was first controlled by China during the centuries just before and after the beginning of the Christian era. From this time and during the Middle Ages, a group of small kingdoms that lived off the profits of the caravan trade formed around the oasis of Tarim. In these principalities, which were deeply marked by the Indian culture as it was transmitted through such great Buddhist centers as Bamiyan and Hadda in Afghanistan and which were also influenced by Iran, there developed an art of modelers and especially painters.

The oldest frescoes of Douldour-âqour date from the period of the flowering of this culture, profoundly imbued with the Buddhist faith. From the middle of the seventh century, however, the oasis of Tarim reentered the orbit of China. The art of this period is represented by the Douldour-âqour mural

painting designated here as No. 39. Conveying a different feeling from the earlier works, it bears the mark of the Chinese art of the T'ang dynasty subtly united with traces of the most ancient Indian style.

The portable paintings of Tun-huang reflect what must have been an important monastic establishment, where the already well-evolved Buddhist pantheon was assimilated by the Chinese world. Occupied for a time by the Tibetans, Tun-huang fell under the domination of the Uighurs before becoming Chinese once again. It is both the result and the evidence of a fantastic mixture of motifs, themes, and beliefs.

Islam, when it took hold, blotted out for many centuries, under its iconoclastic veil, the civilization of ancient Central Asia that served as a vehicle for Buddhism in its progress toward the Far East.

Robert Jera-Bezard

36 HEAD OF A BRAHMAN EO 3669
ACCOMPANIED BY A DEMON (?)
*Douldour-âqour; fragments of a wall
painting; sixth century*
(*a*) H. 7½ *in.* (19 *cm.*), W. 8¼ *in.* (21 *cm.*)
(*b*) H. 10¼ *in.* (26 *cm.*), W. 16⅞ *in.* (43 *cm.*)

Located on the northern part of the Silk Route near the site of Kizil in the Kuça oasis, the Douldour-âqour Buddhist monastery was built around a central court, in the tradition of the monasteries of Northwest India. The fragments of paintings discovered by Pelliot on the walls of a small room located in the northwest corner of this monastery belong to two different periods and are proof of the long activity at the site.

The beautiful head of an old man with a white beard, facing a demon with wrinkled forehead and bristly hair, is related in technique and style to the paintings created at the end of the first style of Kizil (late fifth–early sixth century). The emaciated face of the old man is remarkable for its introspective expression and for its dynamic quality, emphasized by the treatment of the tormented facial features, the beard, and the hair. (R.J.-B.)

Published: *Mission Paul Pelliot en Asie centrale*, vol. 3, *Douldour-âqour & Soubachi* (Paris, 1967), pl. C.

37 FACE AND TORSO OF A DEMON EO 3674
*Douldour-âqour; fragment of a wall
painting; sixth century*
H. 9½ *in.* (24 *cm.*), W. 9 *in.* (23 *cm.*)

Like the preceding work, this painting is related to the ancient Kizil style and illustrates the same repertory of

forms, born of the Buddhist pantheon and legends. Of this demonic being, with mocking smile and rosy flesh-tones, there remains only a part of the face and chest placed against a dark background strewn with flowers. This demon was probably part of the monstrous horde in an "Attack of Māra," a familiar theme in Buddhist iconography which is also illustrated in the hanging scrolls of Tun-huang. The curling locks of another figure appear at the bottom of the fragment. (R.J.-B.)

Published: *Mission Paul Pelliot*, vol. 3, pl. XVII, fig. 30; *Gime Tōyō Bijutsukan* (Tokyo: Kodansha, 1968), pl. 66.

38 BUST OF A FEMALE DIVINITY EO 1122
*Douldour-âqour; fragments of wall
paintings; sixth century*
(*a*) H. 16½ *in.* (42 *cm.*), W. 12⅝ *in.* (32 *cm.*)
(*b*) H. 7⅛ *in.* (18 *cm.*), W. 8⅝ *in.* (22 *cm.*)

The larger of the two fragments shows the bust of a female figure and most of her coiffure, which is decorated with beads. The smaller piece is of a figure whose shoulders are covered with drapery. The main figure is undoubtedly a *devatā* (divinity) and must have been a part of a panel representing a Buddha surrounded by his assistants and worshippers. The absence of a mustache and the type of clothing are the only means of identifying the figure. The face that appears on the smaller fragment seems to be that of a monk. As in the preceding paintings, the treatment of the figures can be related to the ancient Kizil style. (R.J.-B.)

Published: *Mission Paul Pelliot*, vol. 3, pl. XIX, fig. 36.

39 TWO FIGURES BEHIND A EO 1123b
BALUSTRADE
*Douldour-âqour; fragment of a wall
painting; eighth century*
H. 11⅜ *in.* (29 *cm.*), W. 8⅝ *in.* (22 *cm.*)

This fragment, representing two figures behind a bal-
ustrade partly masked by the tail of a peacock, cer-
tainly belonged to an important composition, perhaps
a Buddhist Paradise. Even though it probably origi-
nated in the same sanctuary as the preceding paintings,
it was obviously executed in a very different spirit and
style. The divinities represented are different, and so
are the drawing of the contours and the range of colors.
All of these particular qualities may be explained by
the later date of the painting, which was influenced by
Chinese art of the T'ang dynasty predominating in
Central Asia during the eighth century.

 A comparison can be made with the mural paintings
of the late style of Kumtura, another contempora-
neous site in the Kuça region. (R.J.–B.)

Published: *Mission Paul Pelliot*, vol. 3, pl. XXIII, fig. 44;
O. Monod, *Le Musée Guimet* (Paris, 1966), no. 216.

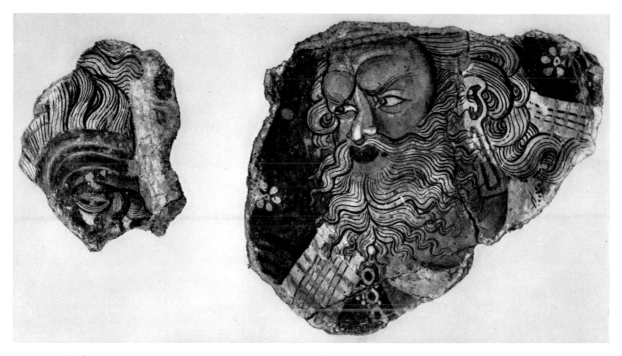

36. Head of a Brahman Accompanied by a Demon (?). *Douldour-âqour; sixth century. Fragments of a wall painting;* H. (*a*) 7½ *in.*, (*b*) 10¼ *in.*

37. Face and Torso of a Demon
Douldour-âqour; sixth century
Fragment of a wall painting; H. 9½ *in.*

38. Bust of a Female Divinity. *Douldour-âqour; sixth century. Fragments of wall paintings;* H. (*a*) 16½ *in.*, (*b*) 7⅛ *in.*

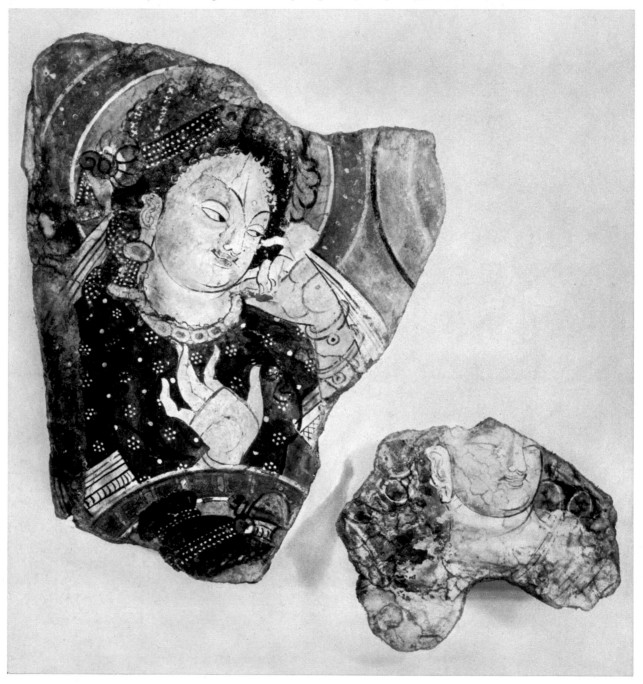

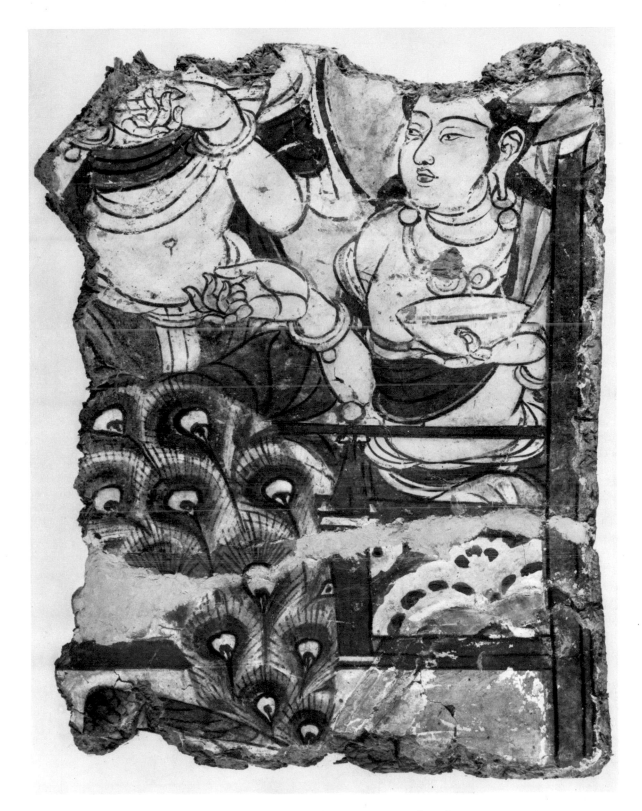

39. Two Figures Behind a Balustrade. *Douldour-âqour; eighth century. Fragment of a wall painting;* H. 11⅜ *in.*

China, Tun-huang: Paintings and Sculpture

Tun-huang, at the western end of Kansu province, was for centuries the city to which Western merchants were obliged to travel if they wished to trade with the Chinese empire. Near Tun-huang a monastery had been installed in a group of natural caves in the cliffs. Founded in the fourth century, it remained until the eleventh century a center of Buddhist culture especially open to Western influences. Following after Sir Aurel Stein, Paul Pelliot (who had learned at Urumtchi of the discovery of an ancient library at Tun-huang) went to the site in February, 1908. After many negotiations, he was given access to this hiding place, which had been walled up during the first half of the eleventh century and which still contained scrolls stacked as high as a man. After several weeks of scrutiny, Pelliot made his selections and acquired between four and five thousand manuscripts, paintings, textiles, and sculptures of wood and bronze. The collections thus assembled (Pelliot expedition, 1906–9) enriched with priceless treasures the Bibliothèque Nationale, as well as the Musée du Louvre and the Musée Guimet, whose donations from the expedition were reunited under the roof of the Guimet in 1945.

Michèle Pirazzoli-t'Serstevens

40 HALF OF A PORTABLE ALTAR EO 1107
 T'ang dynasty (618–907)
 Wood, with traces of polychrome;
 H. 10½ *in.* (26.5 *cm.*), W. 4½ *in.* (11.5 *cm.*)

The Buddha is seated in the Indian manner on a pedestal in the shape of a double lotus, in an oblong niche, under a canopy. The halo behind the head of the Buddha is composed of a lotus in full bloom surrounded by a band of beads and a decoration of rays. His robe of narrow, flowing pleats adheres to the body, leaving the right shoulder uncovered and descending in flattened pleats from the left shoulder. The forearms are broken off. There is a rectangular aperture in the back of the niche.

Cf. the *Makura Honzon* triptych, dated 806, in T. Kuno, *A Guide to Japanese Sculpture* (Tokyo, 1963), pl. 55, and a panel from a traveling altar in A. Priest, *Chinese Sculpture in the Metropolitan Museum* (New York, 1944), no. 38, pl. LXXX.

Published: *Gime Tōyō Bijutsukan* (Tokyo: Kodansha, 1968), pl. 68.

41 DECORATIVE PANEL EO 1174
 Sung dynasty, late tenth–early
 eleventh century. Painting on hemp cloth;
 H. 28¾ *in.* (73 *cm.*), W. 35 ⁷⁄₁₆ *in.* (90 *cm.*)

Two themes are represented here, one above the other. In the lower portion is an incense burner flanked by lions, a motif used in Buddhist sculpture since the time of the Wei (third century); above, two phoenixes facing each other, on lotus pedestals and holding in their beaks a flowering branch, are reminiscent of designs found on T'ang mirrors. The incense burner, a tripod surmounted by the roof of a pagoda crowned with a jewel in the form of flames, is flanked by two lotuses supporting flasks. The lions whose mouths spout flames foreshadow the later Fu dogs. But these very elaborate motifs reveal a certain degeneration. The drawing of the phoenixes lacks the elegance of those shown in profile on eighth-century mirrors. The border, on the other hand, decorated with half rosettes, is classical. (M.P.–D.)

42 PARADISE OF AMITĀBHA EO 1171

Eighth century
Painting on silk; H. 23¼ *in.* (59 *cm.*),
W. 20⅞ *in.* (53 *cm.*)

This is a fragment from the upper area of a composition representing a Buddha preaching to a heavenly assembly. It is probably the paradise of the pure land of the Buddha Amitābha, who appears in the center making the gesture of preaching; he must have been surrounded by four Bodhisattvas, but only three have been preserved, two of whom wear images of the Buddha of conversion in their headdresses. Amitābha is placed in front of two trees whose branches mingle and become interlaced with a richly decorated canopy in the form of a lotus.

The simple treatment of the composition, as well as the line and the style of the drawing, suggests that this work, as Mr. Akiyama has correctly noted, could be one of the oldest examples of portable painting in Tun-huang. (R.J.-B.)

Published: T. Akiyama, *Bijutsu Kenkyū*, no. 252 (May 1967), p. 32; *Gime Tōyō Bijutsukan*, pl. 84.

43 HORSEMEN EO 1153

Eighth–ninth century
Painting on paper; H. 5⅛ *in.* (13 *cm.*),
W. 7½ *in.* (19 *cm.*)

Against a landscape delicately sketched, a rider on a horse with a red mane and tail is followed by a servant whose horse's mane and tail are black. Tints of green, ocher, and pinkish ocher are also employed. Comparing this painting with the scenes on certain banners in the British Museum (ch. XLVI.007, for example) suggests that this fragment represents an episode from the life of Buddha (the Great Departure) and portrays the future Buddha, drawn in the Chinese manner, mounted on Kaṇthaka and accompanied by Chandāka. (M.P.-t's.)

Published: M. Eiichi, "Une peinture de cavaliers à Touen-houang," *Kokka*, no. 425 (1926); *Gime Tōyō Bijutsukan*, pl. 88; O. Monod, *Le Musée Guimet* (Paris, 1966), no. 207 and p. 389.

44 MĀRA'S ATTACK MG 17655

Ninth century
Painting on silk; H. 56⅝ *in.* (144 *cm.*),
W. 44⅛ *in.* (112 *cm.*)

In the center of the composition, seated on a mound strewn with grasses, the Bodhisattva is calling the earth to witness. His halo and nimbus partially conceal the trunk and the numerous branches of the bodhi tree (the tree of enlightenment). Above him, in the midst of the divinities who have come to pay him homage, one sees Mahākāla, a protective deity of terrifying aspect. Māra, accompanied by his daughters who tempt the Bodhisattva, launches the attack at the foot of the throne. All of the deformed and monstrous creatures raised up by the spirit of evil are gathered together in Māra's four armies, one of which is already routed. They throw projectiles—stones, arrows, snakes—which change into flowers. At each side of the painting there are six images of the Buddha, and at the bottom, the Seven Jewels of the Universal Sovereign.

The principal scene is directly inspired by chapter twenty-one of the *Lalitavistara*, a Hīnayāna Buddhist text. The bold, contrasting colors and the detailed execution relate this picture more closely to the miniaturists of Central Asia than to the rest of the work produced in Tun-huang. This explains the Iranian influences that Hackin claimed to see in it; however, the imprint of China appears in many details, such as the dresses of Māra's daughters. *Māra's Attack* may thus be the work of an artist influenced by the miniature painters, as often Manichaean as Buddhist, who worked in the Turfan oasis in Central Asia during the period of Uighur domination. (R.J.-B.)

Published: J. Hackin, *Bulletin archéologique du Musée Guimet*, no. 2 (1921), p. 13; J. Hackin, *Guide catalogue du Musée Guimet* (Paris, 1923), pl. VII, p. 36; E. Matsumoto, *Tonkō-ga no Kenkyū* (Tokyo, 1937), pl. LXXXII; Monod, *Le Musée Guimet*, p. 390; *Gime Tōyō Bijutsukan*, pl. 97.

45 CHOU-YUE KUAN-YIN EO 1136
Late ninth–early tenth century
Painting on paper; H. 20⅞ *in.* (53 *cm.*),
W. 14½ *in.* (37 *cm.*) frontispiece

The Bodhisattva Kuan-yin is seated under a canopy, on a rock in the middle of a lotus pond, near a body of water lighted by the moon. His right foot rests on a lotus and his hands are clasped around the raised left knee. Bamboos and aquatic plants surround him. The divinity wears a tiara decorated with a Dhyāna Buddha and a halo appears behind his head. A mustache outlines the upper lip. Kuan-yin has a bare torso except for scarves and jewelry; the lower part of the body is covered with a flowered skirt.

This type of Chou-yue Kuan-yin goes back, according to tradition, to the T'ang painter Chou Fang. Of the four representations found in Tun-huang (now in the Musée Guimet and the British Museum), this is the only one that does not include the luminous halo (mandorla) around the body of the Bodhisattva. In the other three paintings, Kuan-yin holds a lotus stalk in one hand and a ewer of water in the other. The moon and the water are symbolic of the insubstantiality of things and forms. The significance of the pond with aquatic plants and animals is probably the same as that of the Potala, the mountainous island where the Bodhisattva, surrounded by plants and flowers, is seated on the precious stone of diamond in the position of royal ease. (M.P.-T'S.)

Published: Eiichi, *Tonkō-ga no Kenkyū,* pl. 97 a, p. 344; *Gime Tōyō Bijutsukan,* pl. 94.

46 THE THOUSAND-ARMED MG 17659
 KUAN-YIN
A.D. 981
Painting on silk; H. 74¾ *in.* (190 *cm.*),
W. 49¼ *in.* (125 *cm.*)

The worship of the thousand-armed Kuan-yin seems to have been introduced into China near the end of the T'ang dynasty. Here the Bodhisattva is outlined against a mandorla (nimbus) which forms the background for his thousand arms and the hands whose

palms are decorated with eyes, symbols of his universal vision. In his principal hands, he is holding such attributes as the sun with the three-legged bird and the moon with the hare stealing the water of immortality from under a tree. Kuan-yin is surrounded by many divinities "who come to his assembly," some of which are derived from Hinduism, like Maheśvara on the water buffalo, Mahākāla, Indra, and Brahma. The four Guardian Kings may also be recognized, the ascetic Vasu, and below, against backgrounds of flames, two Vajrapāṇi on either side of the dais. In the lower register, the donor, in Chinese dress and holding an incense burner, stands at one side of a long inscription; on the other side is the Bodhisattva Ti-tsang accompanied by the monk Tao Ming and by a lion with a golden mane.

This painting is dated the eighth Kuei-wei cyclical year of the T'ai ping period (A.D. 981). (R.J.-B.)

Published: Hackin, *Bulletin archéologique du Musée Guimet,* no. 2, pl. 2; Matsumoto, *Tonkō-ga no Kenkyū,* pl. 113 b; Monod, *Le Musée Guimet,* p. 387; *Gime Tōyō Bijutsukan,* pl. 98.

47 THE MIRACLES OF KUAN-YIN MG 17665
Sung dynasty,
late tenth–early eleventh century
Painting on silk; H. 32¾ *in.* (83 *cm.*),
W. 24 *in.* (61 *cm.*)

Standing under a flowered canopy, Kuan-yin holds a lotus in one hand, a ewer in the other; the five jewels are placed in his headdress. The third eye appears on the Bodhisattva's forehead, and he wears a delicate mustache and beard. The body, which is outlined with a fine red line, is wrapped in a scarf and in a garment of the same color with ombré pleats. Cartouches in various colors contain accounts inspired by the Lotus Sūtra (*Saddharma-pundarīka*), of the miracles of Mount Meru, of the Mount of the Diamond, of fire, and of wild beasts. At the bottom of the picture two donors are depicted. Their names are indicated in cartouches: Yin Yuan-ch'ang (in the uniform of an official) and Sin Ts'ing (in the habit of a nun). (M.P.-D.)

Published: Hackin, *Musée Guimet,* p. 42, pl. IX; Monod, *Le Musée Guimet,* p. 189, fig. 204 (detail); *Gime Tōyō Bijutsukan,* pl. 92.

48 DHṚTARĀṢṬRA EO 1172a
Ninth–tenth century
Painting on silk; H. 31½ *in.* (80 *cm.*)
W. 9⅞ *in.* (25 *cm.*)

The Guardian King of the East, identified by the bow
and the long feathered arrow which he is holding, is
trampling on a demon. Above his halo a bluish purple
cloud appears. Dhṛtarāṣṭra is here portrayed in mili-
tary dress. His plumed helmet with ear protectors, his
breastplate, and his short coat of mail draped with a
scarf are treated in a decorative manner.

 Undoubtedly it was in Central Asia that the Guard-
ian Kings of the four points of the compass acquired
the aspect of fierce warriors. This aspect is character-
istic of them in both China and Japan. A similar image,
but reversed, exists in the Musée Guimet's collection
(EO 1172c), proving that the painters used stencils.
(R.J.-B.)

49 VAJRAPĀṆI EO 1172b
Tenth century
Painting on silk; H. 30 5/16 *in.* (77 *cm.*),
W. 9⅞ *in.* (25 *cm.*)

The Bodhisattva Vajrapāṇi (derived, as are the Guard-
ian Kings, from the Indian pantheon) followed the
Buddha everywhere, acting as a guardian spirit and
armed with the Vajra, or thunderbolt. The deity is
here presented in his terrible aspect. He wears a diadem
with a white ribbon floating at each side. His feet rest
on lotus blossoms. The Bodhisattva's exaggeratedly
muscular torso and limbs are ornamented with jewels
—bracelets and small bells, reminiscent of his Indian
origin—but the strong musculature and the dynamic
stance are in the Chinese manner. (R.J.-B.)

50 SĀMANTABHADRA MG 17770
Tenth century
Painting on silk; H. 23¼ *in.* (59 *cm.*),
W. 14⅛ *in.* (36 *cm.*)

The Bodhisattva, in princely dress, holds a stem with
three lotus buds (pink, reddish violet, and blue) in his
right hand. The transparency of the floating scarf is
treated with great skill. The smallness of his waist, the
length of his arms, the sway of his hips, as well as the
face suggest Indian influence; this is balanced, how-
ever, by the Chinese inscription in the cartouche,
which is all that enables one to identify the Bodhisattva
in this picture. In the other two paintings in the collec-
tion in which he is represented, Sāmantabhadra is
accompanied by his vehicle (or mount), an elephant.
(R.J.-B.)

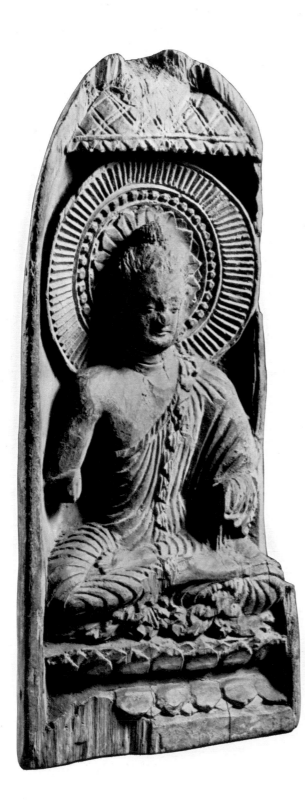

40. Half of a Portable Altar
Tun-huang; T'ang dynasty, 618–907
Wood, with traces of polychrome; H. 10½ *in.*

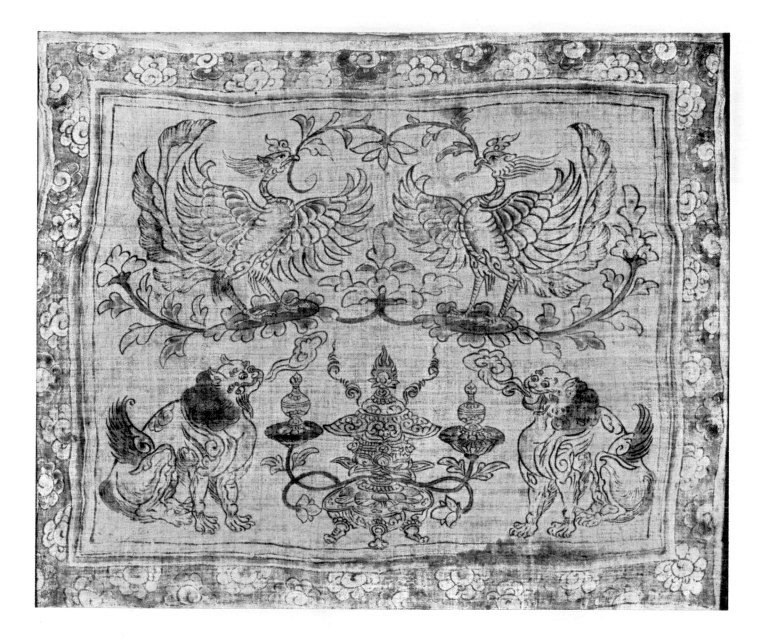

41. Decorative Panel. *Tun-huang; Sung dynasty, late tenth–early eleventh century. Painting on hemp cloth;* H. 28¾ *in.*

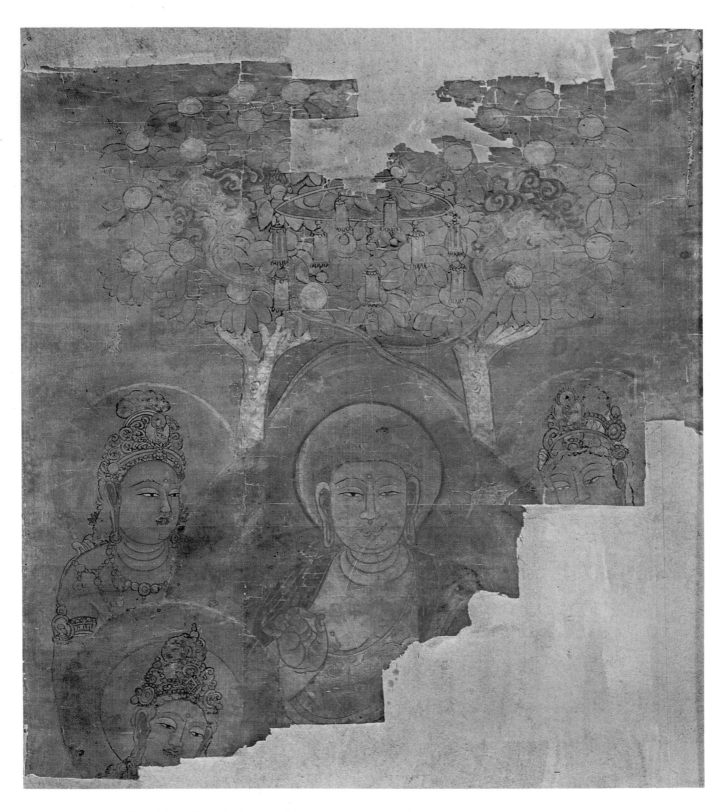

42. Paradise of Amitābha. *Tun-huang; eighth century. Painting on silk;* H. 23¼ in.

43. Horsemen. *Tun-huang; eighth–ninth century. Painting on paper;* H. 5⅛ *in.*

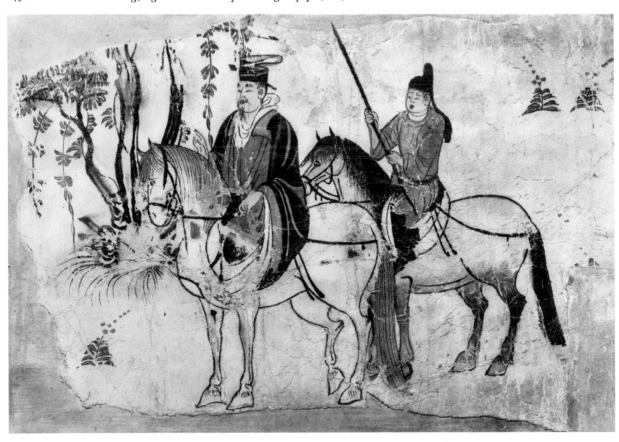

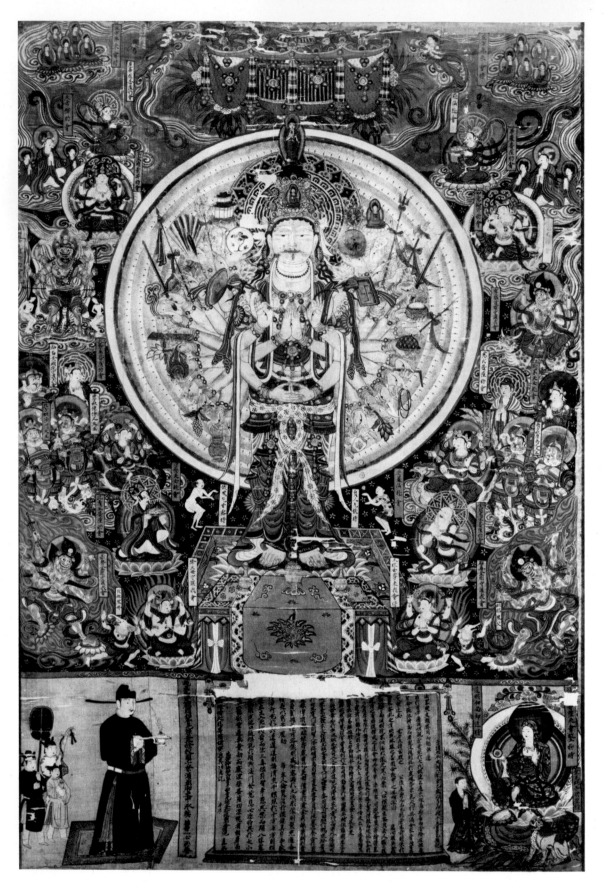

46. The Thousand-Armed Kuan-yin. *Tun-huang;* A.D. 981. *Painting on silk;* H. 74¾ *in.*

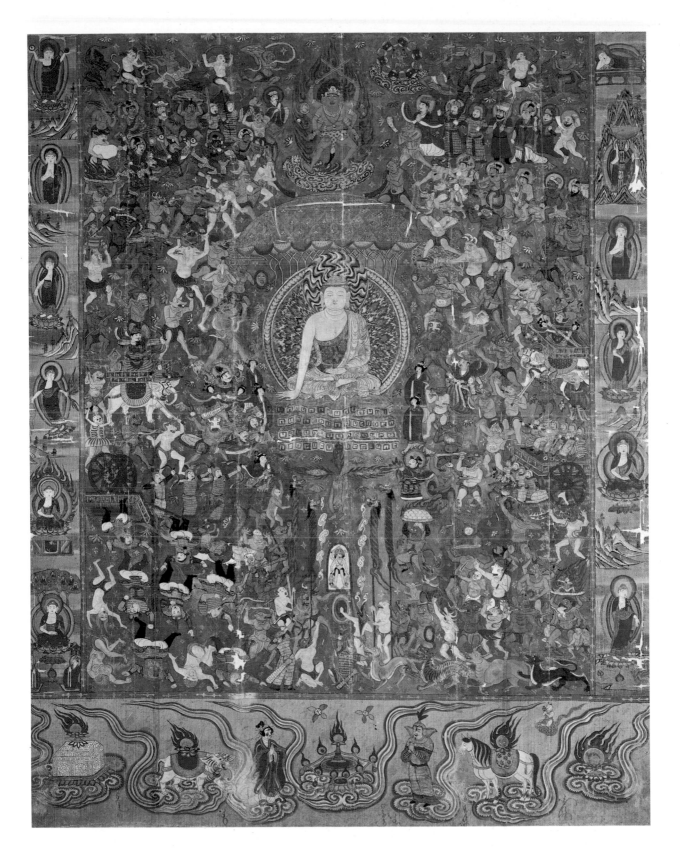

44. Māra's Attack. *Tun–huang; ninth century. Painting on silk;* H. 56⅝ *in.*

44. *Detail*

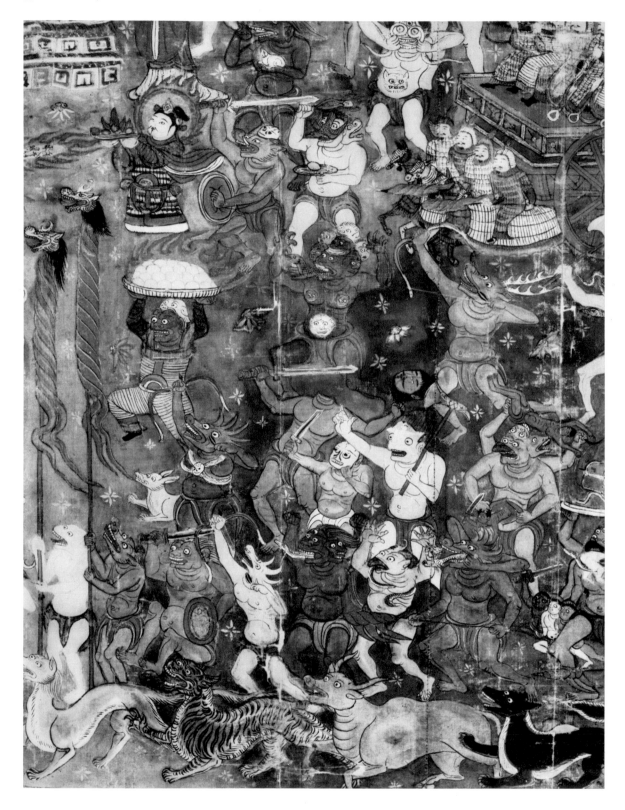

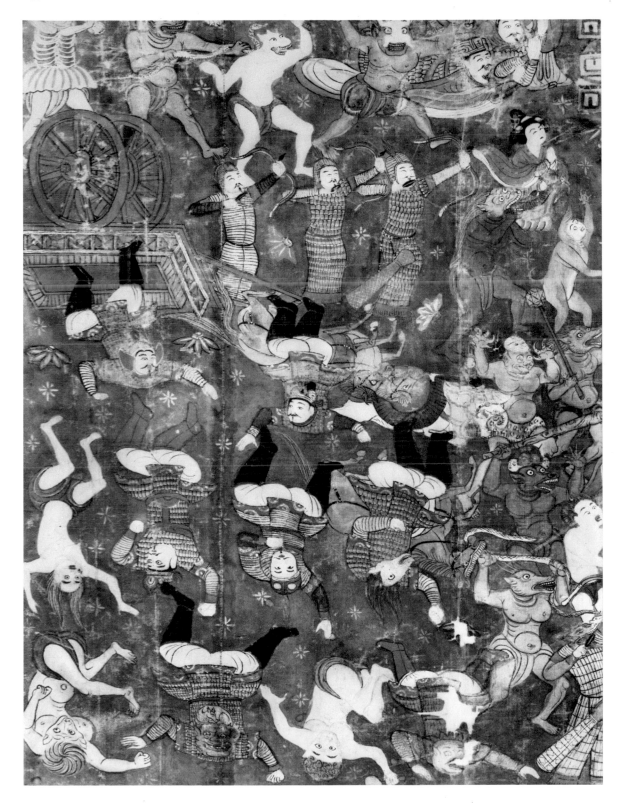

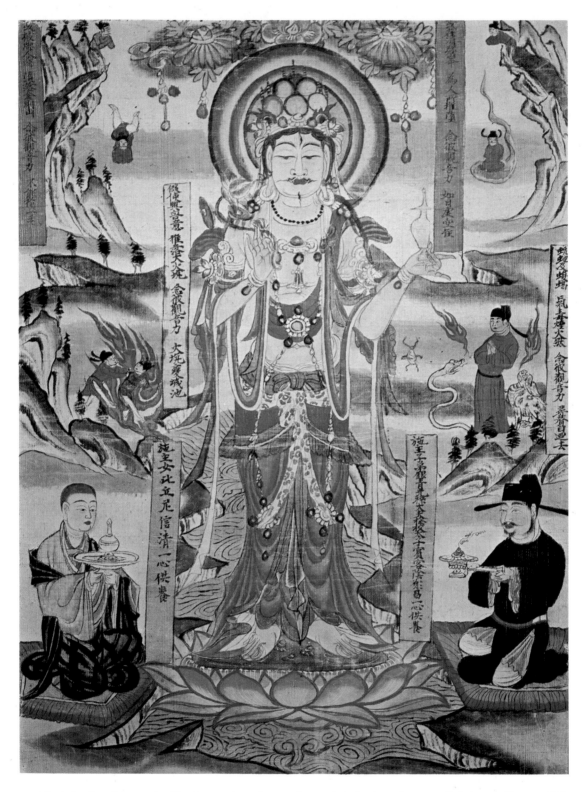

47. The Miracles of Kuan-yin. *Tun-huang; Sung dynasty, late tenth–early eleventh century. Painting on silk;* H. 32¾ *in.*

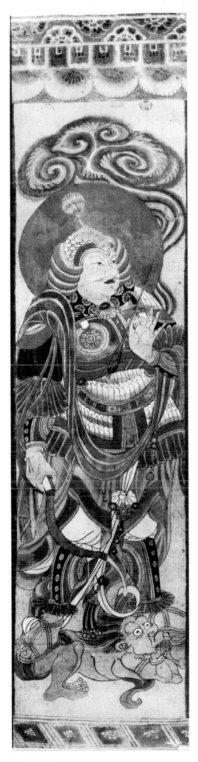

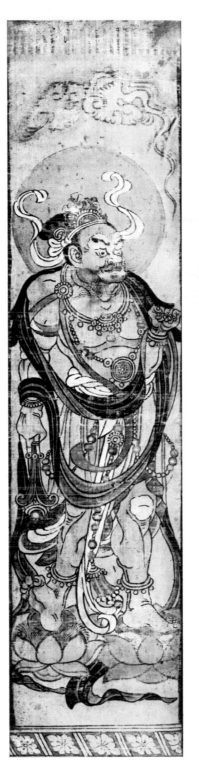

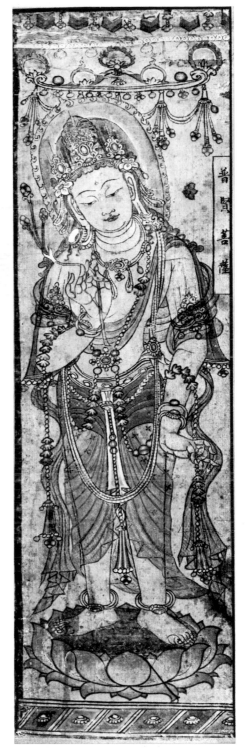

48. Dhṛtarāṣṭra
Tun-huang; ninth–tenth century
Painting on silk; H. 31½ *in.*

49. Vajrapāni
Tun-huang; tenth century
Painting on silk; H. 30⅚ *in.*

50. Sāmantabhadra
Tun-huang; tenth century
Painting on silk; H. 23¼ *in.*

China: Archaic Ivories and Bronzes

ARCHAIC ivories (of the Shang period) are still rarities in Western collections. It is worth noting that during the Shang period, and even under the Chou, the elephant was still native to northern and central China.

In 1923, the Louvre acquired a very remarkable carved ivory, later transferred to the Guimet, which is included in this exhibition (No. 51). Others were purchased by the Musée Guimet after it was designated the Department of Asian Arts of the National Museums of France.

As for the collection of archaic Chinese bronzes belonging to the Louvre, which was conveyed to the Musée Guimet in 1945, its formation began in 1910–12 with the objects brought back by Paul Pelliot, the bequests of Nissim de Camondo, and the first gift of a great connoisseur, D. David-Weill.

Important gifts (from Bing, Sauphar, Curtis) followed until 1939, and were supplemented by the purchases of Otto Karlbeck in China (1934)—acquisitions that were made possible by the contributions of many donors. From 1944 on, and particularly after 1946, purchases were resumed. Additional bequests (H. Rivière in 1952) and gifts (from A. Kahn in 1949, D. David-Weill in 1952, and Michel Calmann in 1962) enriched the collection with exceptional pieces.

D. David-Weill's sumptuous gift of 1952 brought to the Musée Guimet its most beautiful Shang weapons and its inlaid bronzes from Chin-ts'un. In addition, in 1972, his children presented to the museum two long-celebrated *kuei* and two "animal style" plaques dating from the Chou dynasty.

Michèle Pirazzoli-t'Serstevens

51 T'AO-T'IEH MASK　　　　　　　EO 2549
Shang dynasty, Anyang period,
twelfth–eleventh century B.C.
Ivory; H. 3¼ *in.* (8.3 *cm.*), W. 3½ *in.* (9.4 *cm.*),
DEPTH ½ *in.* (1.1 *cm.*)

The mask, carved from a thick section of ivory, must have served as an inlay, as is indicated by the perforations at the sides. It has a pale yellow patina. The contrast between the principal motifs, in smooth relief, and the background covered with square, engraved spirals, enables us to attribute it, by analogy with Shang bronzes, to Style V, defined by Loehr as "First appearance of motifs in relief: the motifs rise above the ground spirals, which may be eliminated alto-

gether."[1] These motifs comprise the horns of the mask, eyebrows, eyes, a lozenge on the forehead, two broad, inward-curving nostrils, and on each side a *k'uei* dragon in the form of a serpent with clawed feet, and a silk-worm which follows the curve of the ivory. The spaces are filled with non-zoomorphic forms; toward the top, they form a sort of ideogram (*cf.* the *li-ting* of the Barlow Collection in M. Sullivan [London, 1963], pl. 145). (D.L.-G.)

Acquired in 1923; formerly Paul Mallon Collection.

Published: Cheng Te-k'un, *Shang China* (Toronto, 1960), pl. xxv; R. S. Jenyns, *Chinese Art* (New York, 1965), vol. 4, pl. 108.

1. M. Loehr, *Ritual Vessels of Bronze Age China*, exhibition catalogue, Asia House Gallery (New York, 1968), p. 13.

Eastern Chou period, seventh–fifth century B.C.
Ivory; L. 6¼ *in.* (16 *cm.*), W. 1¼ *in.* (3.2 *cm.*),
THICKNESS ⅜ *in.* (1 *cm.*)

The decoration is composed of interlaced and curving ribbons, punctuated by hooks, volutes and dots, and ending in dragons' heads. The flat parts are bordered by a delicate, raised, thread-like edge; flowing, intertwined motifs unfold around them.

The rhythmic composition achieved by these parallel, oblique lines and curves is distributed on each side of a small, flat rectangle with rounded corners, and associates in a continuous movement geometric and zoomorphic elements. The decoration, carved as it is on many different levels and with deep incisions, gives the effect of pierced work. (D.L.-G.)

Acquired in 1959; formerly J. Bataille and S. H. Minkenhof collections.

Published: H. F. E. Visser, *Asiatic Art* (Amsterdam, 1948), pl. 215, no. 35 a.

53 KUANG MA 1640

Shang dynasty, Anyang period,
thirteenth–eleventh century B.C.
Bronze; H. 8½ *in.* (21.5 *cm.*),
W. 9¾ *in.* (24.8 *cm.*)

This spouted vessel for alcoholic beverages has a zoomorphic handle in the form of a bird of prey and a cover in the form of an imaginary animal.

The decoration is compartmentalized, in relief, against a background of round spirals. On the oval, hollow foot are four flanges, separating *k'uei* facing each other in pairs. On the body, identical *t'ao-t'ieh* appear on both sides. On the neck, on the underside of the spout, is a *t'ao-t'ieh* mask; behind a flange and toward the handle is the head of a predatory dragon. On the cover a sort of crest, similar to the vertical flanges on the body and the foot, extends from the horns of the monster's head at one end to the raised ears of the *t'ao-t'ieh* head in low relief at the opposite extremity.

The monster with horns like mushrooms has the eyes of a *t'ao-t'ieh* but the muzzle of a wild beast with bared teeth. Along the crest are elements of dissolved masks. The *t'ao-t'ieh* mask, at the other end of the crest, has a sort of projecting tongue which might have been used to raise the cover. (M.P.-t's.)

Acquired in 1954; formerly Kawai Collection, Kyoto.

54 SACRIFICIAL VESSEL IN THE MA 1655
FORM OF A SHAO LADLE

Shang dynasty, Anyang period,
fourteenth–eleventh century B.C.
Bronze; H. 6½ *in.* (16.5 *cm.*),
L. 14⅜ *in.* (36.5 *cm.*),
DIAM. 5 *in.* (12.5 *cm.*)

The bowl of the ladle is cylindrical and concave, the mouth and the base being wider than the midsection. On the decorated band around the mouth, against a background of angular spirals, "whirlwinds," composed of commas turning like a propeller around a small central circle, alternate with lozenges in groupings of six. A similar, decorated band around the base has the same background, but here the "whirlwinds" alternate with birds in profile. Under the base is a caster's mark of crossed threads, in relief.

The handle, sleek and simple, is bent gently in the form of an S. It is attached to the bowl by means of the head of a *t'ao-t'ieh* with the horns of a water buffalo; the end of the handle, slightly deviated toward the right, is made of the curled-up body of an animal which has a *t'ao-t'ieh* head with ram's horns. The body of the animal is provided with a sort of spinal column and is engraved with hooks. (M.P.-t's.)

Acquired in 1955; formerly Lochow Collection.

Published: G. Ecke, *Sammlung Lochow: Chinesische Bronzen* (Peking, 1943), pl. xv.

55 TSUN IN THE FORM OF AN EO 1545
ELEPHANT

Shang dynasty, late Anyang period, or early
Western Chou, twelfth–eleventh century B.C.
Bronze, with green patina;
H. 24¼ *in.* (64 *cm.*), L. 37¾ *in.* (96 *cm.*)

The elephant stands on all four feet, his trunk raised, ears forward. The tip of the trunk was repaired with tin, probably at the beginning of the twentieth cen-

tury. There is an opening on the elephant's back; originally it had a cover.

The vessel is entirely covered with decorations except for the lower part of the legs. On each flank, against a background of spirals, is a large *t'ao-t'ieh* mask formed of two *k'uei* with bands having appendages in the form of hooks, their bodies being emphasized by round spirals. On the elephant's head, the *k'uei* motifs are arranged around the large round eyes.

The under part and the top of the trunk, the ears, the underside of the belly, the rear, the short tail and the midsection of the legs have a decoration of scales arranged in vertical bands.

This vessel, which was used for storing alcoholic beverages, belongs to the same stylistic family as the *tsun* with two sheep in the Nezu Art Museum (Tokyo) and the one with the two rams in the British Museum. Its style also relates it to the bronze drum of the Sumitomo Collection. (M.P.-t's.)

Camondo Bequest, 1911.

Published: O. Sirén, *Les Arts anciens de la Chine* (Paris, 1929), vol. I, pl. 50; *Gime Tōyō Bijutsukan* (Tokyo: Kodansha, 1968), pl. 101.

56 TING AA 76a
*From Li-yü (Shansi); Eastern Chou
period, first half of fifth century* B.C.
Bronze; H. 7¼ *in.* (18.6 *cm.*),
DIAM. 7¼ *in.* (18.6 *cm.*)

The belly of this round, tripod vessel is decorated in very low relief and two bands of decoration are separated at the widest part by a raised string incised with oblique lines. The lower band is composed of dragons, their heads turned back, their ribbon-like bodies decorated with spirals. Leaf motifs with spirals inscribed in them descend from this band.

The upper band is composed of similar dragons, this time interlaced. The cover has two of these concentric bands, surrounding a central motif. On the outer band, the decoration is much like that of the upper band on the vessel, in low but less dense relief, showing more of the background. Superimposed on this decorated background are three water buffaloes in high relief. On the inner band, separated from the preceding

one by a narrow, cord-patterned strip, are large volutes ornamented with spirals, radiating around an "eye" marked with dots. Resting on the lower part of this band, three realistic ducks in the round, their feathers indicated by incisions, alternate with the water buffaloes below.

The central motif of the cover, composed of three commas united on a background of spirals, encircles a movable ring incised with oblique lines. Two square handles, upright and slightly curved inward, are decorated on their edges with a band engraved with a cord motif, and on each side with bands of spirals and volutes. The feet are attached to the *ting* with animal masks in relief, set off by incisions. (M.P.-t's.)

Acquired in 1935; formerly Wannieck Collection.

Published: Sirén, *Les Arts anciens de la Chine*, vol. I, pl. 97; S. Umehara, *Shina Kodō Seika* (Osaka, 1933), vol. III, pl. 164.

57 RECLINING WATER BUFFALO MA 1081
*From Li-yü (Shansi); Eastern Chou
period, fifth–third century* B.C.
Gilt bronze, with green patina;
H. 2⅜ *in.* (6.1 *cm.*), L. 5⅜ *in.* (13.6 *cm.*),
W. 2 *in.* (4.8 *cm.*)

The buffalo's right front leg is extended. A ring in his nostrils is attached to a halter which goes under the muzzle and around the horns, and is fastened to a second ring on the forehead. The halter has three tassels, one on each side of the neck and one underneath. Traces of incisions under the patina suggest the hairs of the animal's coat. (M.P.-t's.)

Acquired in 1952; formerly Wannieck Collection.

Published: Sirén, *Les Arts anciens de la Chine*, vol. III, pl. 34 b.

58 TUI MA 1383
*From Chin-ts'un (Honan); late
Eastern Chou period, third century* B.C.
Bronze, inlaid with silver and gold;
H. 6 *in.* (15.2 *cm.*), DIAM. 11½ *in.* (29 *cm.*)

A round, bronze bowl, inlaid with silver and gold, is supported by a foot-ring. The cover is surmounted by four birds whose arching bodies form rings, and when the cover is turned over, it rests on the birds' heads.

Two rigid handles are attached to the belly. Archaistic (following a Western Chou type), each is decorated with the head of a horned animal whose eyes are inlaid with gold; a rectangular appendage seems to support the handles. The vessel is inlaid with silver in an asymmetrical pattern of bands and volutes. On the flat and slightly raised surface of the cover, the volutes surround a quatrefoil motif whose center is inlaid with gold. (M.P.-t's.)

Acquired in 1953; formerly Kawai Collection, Kyoto.

Published: S. Umehara, *Rakuyō Kinson*, rev. ed. (Kyoto, 1944), p. 23, pl. 24, S. Umehara, *Nihon Seika* (Osaka, 1961), vol. V, p. 369; M. Loehr, *Ritual Vessels of Bronze Age China*, exhibition catalogue, Asia House Gallery (New York, 1968), no. 74.

59 PAIR OF SCABBARD MOUNTS MA 1077 (1–2)
From Chin-ts'un (Honan); Warring
States period, fourth–third century B.C.
Bronze, inlaid with gold and silver;
each in two sections:
(a) L. 5 *in.* (12.7 *cm.*), DIAM. 1⅛ *in.* (2.8 *cm.*)
(b) L. 3⅛ *in.* (7.7 *cm.*), DIAM. 1¼ *in.* (2.9 *cm.*)

The longer section of each mount ends in a dragon's head. The silver-inlaid horns curve downward, piercing the dragon's ears which, like the rest of the head, are inlaid in gold. Its talons clinging to the dragon's upper jaw, its tail covering the lower jaw, and its body arching over the mouth, a bird of prey inlaid with silver pecks at the muzzle. On each side of the monster's lower jaw is a spiral inlaid with silver. Two dragons, one on either side of the mount, comprise the rest of the decoration. On the part that adjoins the shorter tube, three gold commas within four gilded circles are inscribed on a bronze background.

The shorter section is decorated with triangles and spirals inlaid in gold and silver. A raised band covered with a thin layer of silver is perforated with two holes for attachment to the scabbard. (M.P.-t's.)

Gift of D. David-Weill, 1952.

Published: Umehara, *Shina Kodō Seika*, vol. VI, no. 48; B. Karlgren, "Notes on a Kin-ts'un Album," *Bulletin of the Museum of Far Eastern Antiquities*, no. 10 (1938), pl. III and pp. 73–74.

51. T'ao-t'ieh Mask. *China; Shang dynasty, Anyang period, twelfth–eleventh century* B.C. *Ivory; H. 3¼ in.*

52. Ritual Object. *China; Eastern Chou period, seventh–fifth century* B.C. *Ivory;* L. *6¼ in.*

53. Kuang. *China; Shang dynasty, Anyang period, thirteenth–eleventh century* B.C. *Bronze;* H. 8½ *in.*

54. Sacrificial Vessel in the Form of a Shao Ladle
China; Shang dynasty, Anyang period, fourteenth–eleventh century B.C.
Bronze; H. *6½ in.*

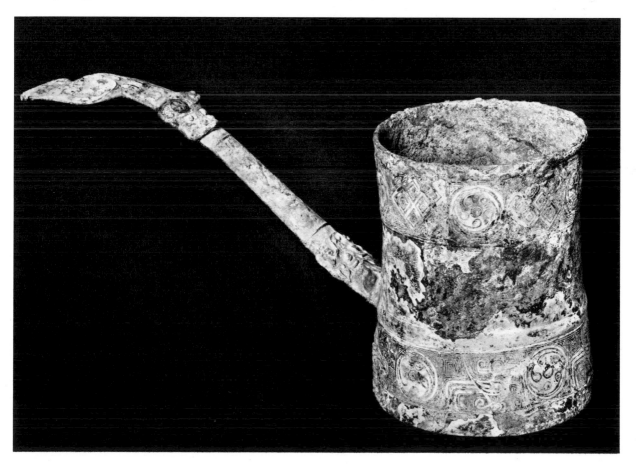

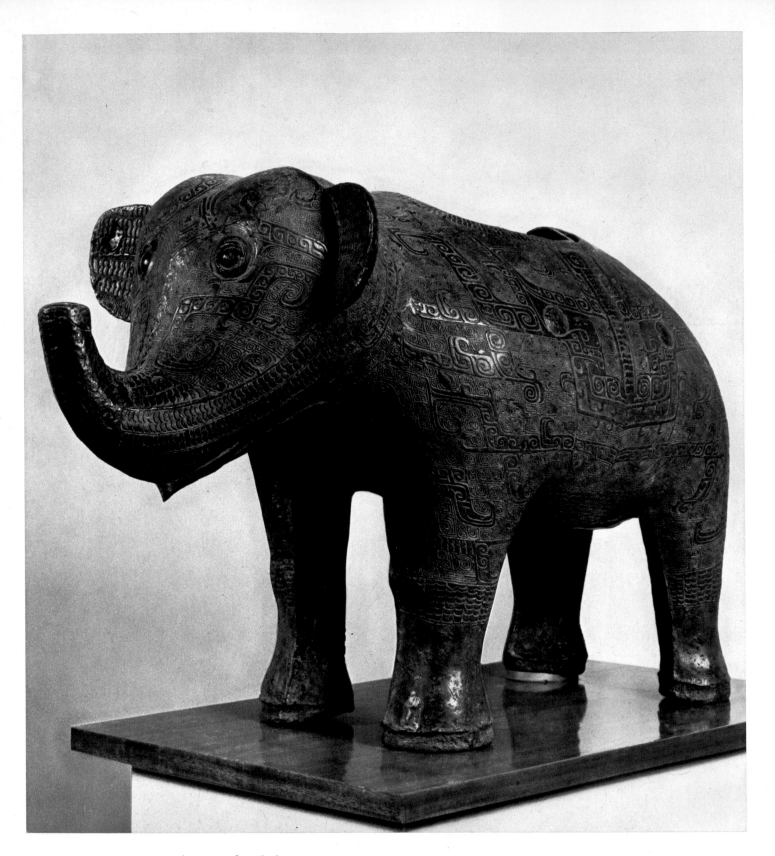

55. Tsun in the Form of an Elephant
China; Shang dynasty, late Anyang period or early Western Chou, twelfth–eleventh century B.C.
Bronze, with green patina; H. 24¼ *in.*

56. Ting. China; Eastern Chou period, first half of fifth century B.C. Bronze, H. 7¾ in.

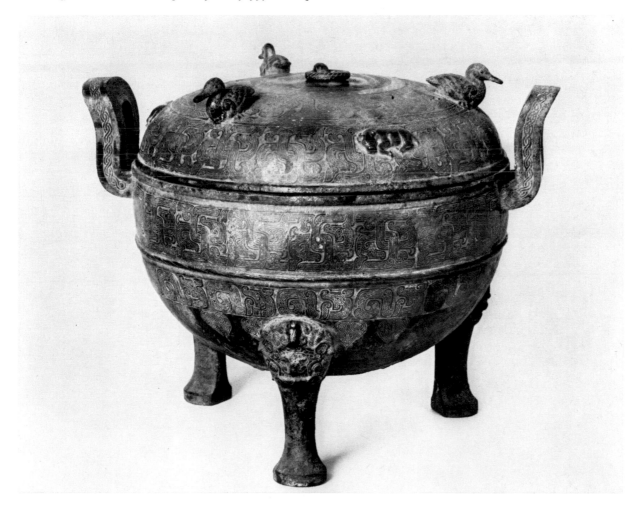

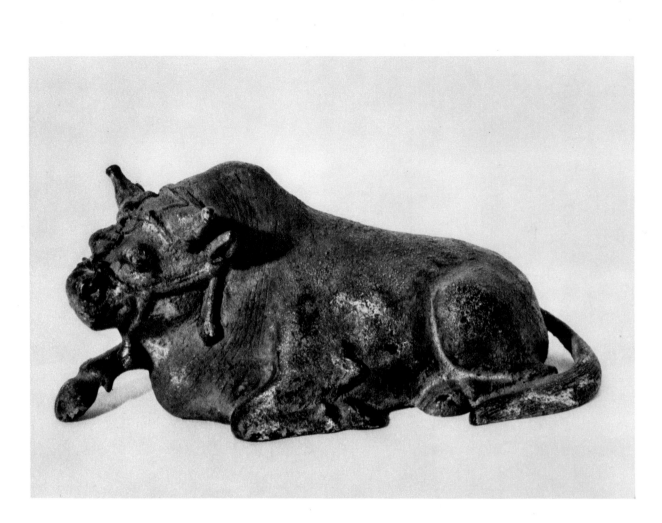

57. Reclining Water Buffalo. *China; Eastern Chou period, fifth–third century* B.C. *Gilt bronze, with green patina;* H. 2⅜ *in.*

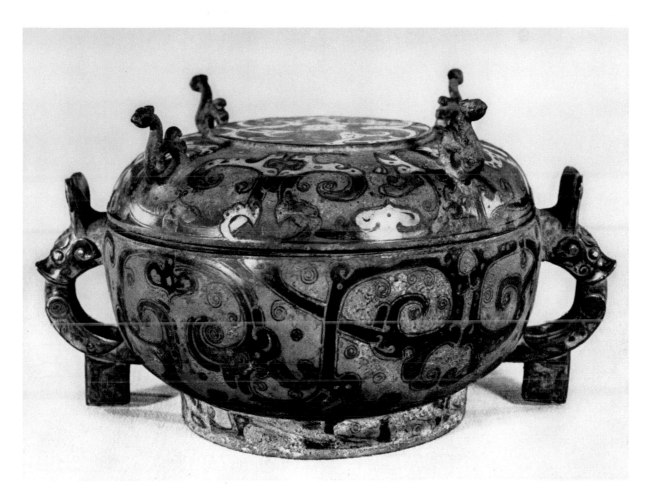

58. Tui
China; late Eastern Chou period, third century B.C.
Bronze, inlaid with silver and gold; H. 6 *in.*

59. Pair of Scabbard Mounts
China; Warring States period, fourth–third century B.C.
Bronze, inlaid with gold and silver; each in two sections:
(a) L. 5 *in.*, (b) L. 3⅛ *in.*

China: Buddhist Gilt Bronzes

THE few hundred Buddhist ex-votos (fifth–tenth century) that belong to the Musée Guimet come from the following sources: the Paul Pelliot expedition and bequest (1910), the very important gift of Osvald Sirén (1927), and purchases made by Joseph Hackin in Japan (1933). Recent acquisitions have made it possible to round out this collection.

Michèle Pirazzoli-t'Serstevens

60 BUDDHA IN ABHAYA AND MG 18911
VARA MUDRĀ
Liu Sung dynasty, A.D. 478
H. 9¾ *in.* (25 *cm.*)

The Buddha is seated in the *lalitāsana* position on a seat supported by a pedestal with four feet. The center of the nimbus behind him is decorated with a floral motif surrounded by a conventional leaf pattern, then by flames. The pierced border contains five flying *apsaras* alternating with four stylized flowers. The inscription on the back consists of forty-one characters, six of which are illegible.

An identical piece (Carroll B. Malone Collection, U.S.A.), which forms a pair with this one, has the same inscription on the back, making it possible to reconstruct the full inscription. The text is as follows:

> In this second year of the Cheng-ming Era [A.D. 478], year of the Wou-wou sign, the tenth day since the beginning of the seventh moon, the faithful Yang Kao respectfully makes this statuette so that his deceased parents, as well as his wife, his children and his brothers, may all meet the Buddhas and rejoin the three Jewels.

Acquired in 1937.

(H.C.-L.)

61 ŚĀKYAMUNI AND EO 2604
PRABHŪTARATNA
A.D. 518
H. 10¼ *in.* (26 *cm.*) ill. p. 19

The two Buddhas, each with an aureole, are seated on a bench that rests on a pierced base. In the opening at the front of the base is an incense-burner carried by an *apsara*, flanked by two seated lions. Above, on either side of the incense-burner and forming a low relief against the pedestal, are two monks in adoration, one holding a lotus stem, the other a censer. The theme of the mystical conversation of the two Buddhas had already appeared in the Yün-kang and Lung-men caves. It is treated here in the flamboyant style characteristic of the first quarter of the sixth century: elongated flat torsos, sharp faces on long necks, linear but supple drapery, and pointed aureoles with incised flames.

On the back, and on the sides of the base, is the following inscription:

> On this 16th day of the second moon of the Hi-p'ing Era [518], the brothers T'an-jen and Tao-mi, monks of the Ling-p'i Monastery of the [district of] P'ou-wou [in Hopei] have respectfully ordered to be made in behalf of their parents and of themselves the two Buddhas Prabhūtaratna and Śākyamuni to honor . . . [3 characters illegible]. At the moment when their father Wang K'ang serves the Buddha . . . [2 characters], their mother Tcheng . . . [4 characters].

(M.P.-t's.)

Acquired in 1925; formerly Peytel Collection.

Published: H. Münsterberg, "Buddhist Bronzes of the Six Dynasties Period," *Artibus Asiae*, vol. IX, no. 4 (1946), pp. 275–315, pl. 10; M. Seiichi, *Bronze and Stone Sculpture of China* (Tokyo, 1960), pl. 120; *Gime Tōyō Bijutsukan* (Tokyo: Kodansha, 1968), pl. 107.

62 KUAN-YIN MA 2548
Late Northern Ch'i dynasty, 550–77
H. 4 *in.* (10 *cm.*)

Kuan-yin is seated in the *lalitāsana* position on a round seat which is encircled at mid-height by a beaded rope,

the right leg folded, the foot hidden beneath the robe, the left leg resting on a lotus flower. Kuan-yin's face is round and smiling. The halo is ornamented with small, etched flames. The hair is arranged in bands on the temples, with a chignon on top, and the diadem consists of three florets separated by two small medallions. Two streamers with engraved decoration fall from the diadem to the shoulders. The robe, exposing the upper chest, forms a rounded shawl in the back. The skirt, which falls over the right knee and leg to ankle level, has a scalloped border, turned under and visible from the back.

The right hand is in *abhayamudrā*; the left, in *varamudrā*. The pointed ends of a pleated scarf fall over each arm. A double string of beads, fastened to the shoulders by two medallions, falls down the chest; on the abdomen is a medallion where the two strings of beads cross before falling around the knees. A single strand of beads follows the neckline and holds a tassel. (M.P.-t's.)

Acquired in 1962; formerly Ramet Collection.

63 BODHISATTVA MA 2559
Northern Ch'i dynasty, 550–77
H. 7¼ in. (18.5 cm.)

The Bodhisattva stands on a pedestal in the form of a lotus, feet turned outward slightly, the weight of the body resting on the right leg, the left leg slightly bent. The left hand is in *abhayamudrā*. The face, which widens at the jaws, wears a somewhat tentative smile. The eyes are half-closed. Above the parted hair is an elaborate headdress, surmounted on each side by a medallion ornamented with a central button, from which two panels of material descend from angular supports to the shoulders. The collar of the underdress is draped in pointed folds on the breast. The mantle falls in straight pleats ending in floating panels on each side of the legs. Over the knees and the ankles, the pleats assume a "keyhole" shape. A floating scarf forms symmetrical panels on either side of the forearms. Starting at the shoulders, a long rope of beads separated by small, flat medallions, and clasped by a large

medallion, extends almost to the knees. The smooth back contains two studs that once held a halo. (M.P.-t's.)

Acquired in 1963; formerly Ramet Collection.

Published: D. Lion-Goldschmidt and J. C. Moreau-Gobard, *Arts de la Chine* (Fribourg, 1960), pl. 115.

64 MAHĀ-VAIROCANA, COSMIC MA 25
BUDDHA
Sui dynasty, 589–618
H. 5½ in. (14.1 cm.)

This standing Buddha wears a cloak with parallel folds covering both shoulders. The hair is in stylized curls, and there are three creases in the neck. The right hand makes the gesture of *abhayamudrā*; the left hand, that of *varamudrā*. On the front of the cloak are modeled the sun, the moon, two *apsaras*, Mount Meru (formed of a rock beaten by waves and borne by interlaced dragons), a Buddhist sanctuary, and scenes of hell. On the back, which is flatter, other personages modeled in relief evoke the Six Ways (the damned, *preta*, wild animals, *asura*, humans, and Buddha), as well as Kṣitigarbha (King of Hell) sitting on a throne. The theme is borrowed from the *Avataṃsaka Sūtra* which makes Vairocana the master of all the universe. This iconography first appeared at Khotan, passed on to Kuça (Kizil Cave), then appeared in cave no. 425/P. 135 of Tun-huang (early sixth century). There are various interpretations. (M.P.-D.)

Acquired in 1943; formerly Bouasse-Lebel Collection.

Published: J. Auboyer, *Le Trône et son symbolisme dans l'Inde ancienne* (Paris, 1949), pp. 149–50.

65 GUARDIAN DEITY MG 17078
Late sixth–early seventh century
H. 4½ in. (11.5 cm.)

This standing figure was originally part of an altar. The torso is inclined toward the right, the left arm raised, fist clenched; the right arm hangs down, its hand broken off. The figure has wide-open almond eyes, jutting eyebrows, and a deeply wrinkled forehead. The head is topped by a tiara with a ribbon that

falls in streamers to the waist and above the ears are little rosettes of ribbon. The nude torso and arms accentuate the musculature of the neck, biceps, and forearms. A long skirt, held by a belt, falls to the feet (now broken off), while a scarf, knotted above the waist, floats on either side, following the curve of the body. There are remnants of blue, green, and red polychromy on the surface. The flat treatment of the back and the simple movement of the draperies, combined with the realistic modeling of the chest, arms, and face, enable us to date this piece between the late Sui and early T'ang dynasties. It should be compared with one of the guardians of the gilt bronze altar, dated A.D. 593, in the Boston Museum of Fine Arts. (F.D.)

Gift of O. Sirén, 1927.

Published: S. Mizuno, *Bronze and Stone Sculpture in China* (Tokyo, 1960), pl. 124; "Documents d'art chinois de la collection O. Sirén," *Ars Asiatica*, vol. VII (1925), pl. XXVI, no. 248.

66 CELESTIAL DANCER MG 17079
T'ang dynasty, eighth century
H. 4¾ *in.* (12.2 *cm.*)

This dancing figurine must have once been part of a group, judging from the fragment of a stud on the top of the right foot. It more likely belonged to a divine orchestra such as those sculpted in relief on the side walls of Wang-fo t'ong (Cave of the 10,000 Buddhas) of Lung-men, dated A.D. 680 and, according to Mizuno Seiichi, dedicated to the Amitābha Buddha. The accentuated *tribhanga* (S-curve of the body), the bare torso with crossed scarves, the legs outlined by the drapery, the floating ribbons in the hair, with one end gracefully held in the right hand, the full face with a somewhat heavy chin—all these things are more reminiscent of the style of T'ien-lung shan. This type of representation, rare in sculpture, is very popular in many paintings, especially those of Tun-huang. (M.P.-D.)

Acquired in 1927. Gift of O. Sirén.

Published: "Documents d'art chinois," pl. XXVI, no. 259.

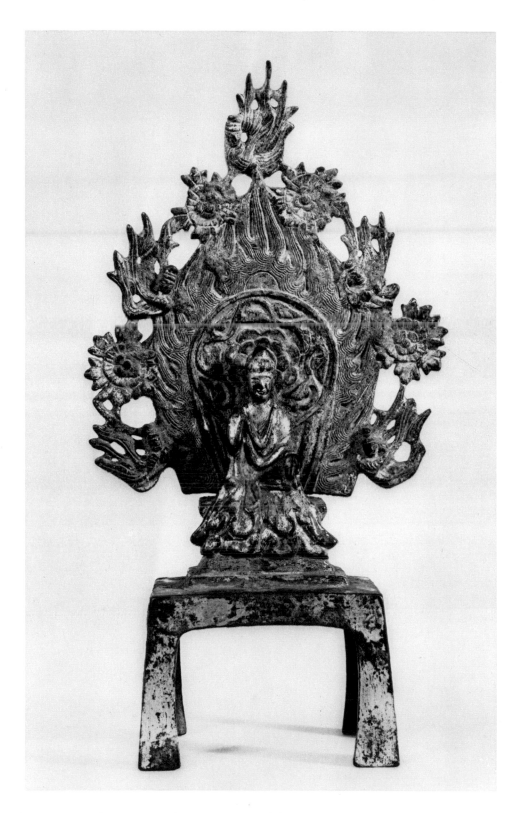

60. Buddha in *Abhaya* and *Vara Mudrā*. *China; Liu Sung dynasty,* A.D. 478. *Gilt bronze;* H. 9¾ in.

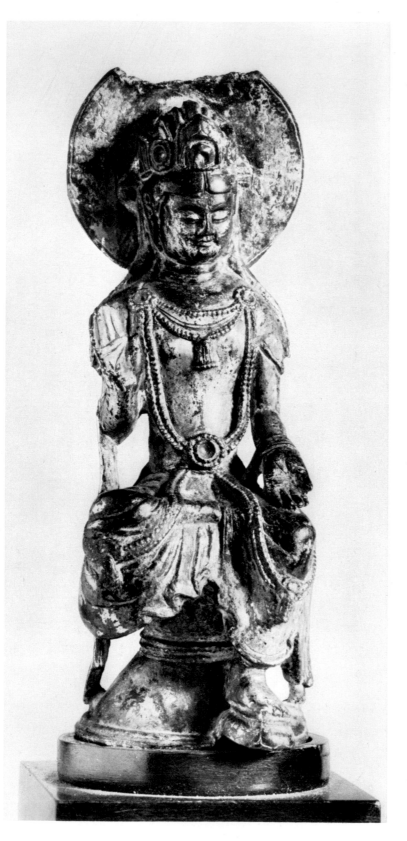

62. Kuan-yin
China; late Northern Ch'i dynasty, 550–77
Gilt bronze; H. *4 in.*

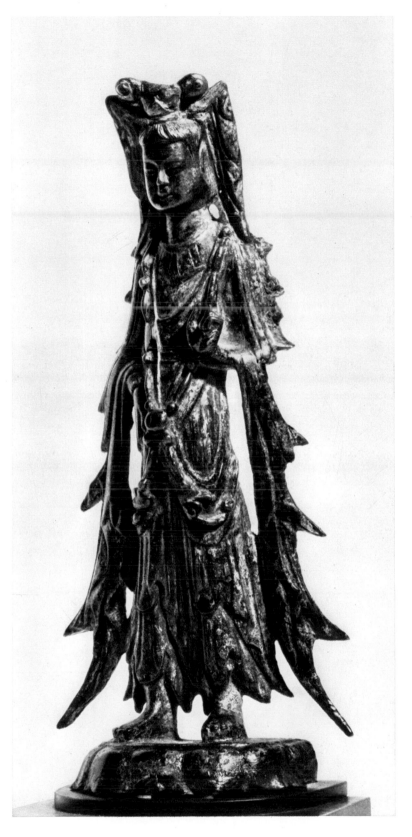

63. Bodhisattva
China; Northern Ch'i dynasty, 550–77
Gilt bronze; H. 7¼ *in.*

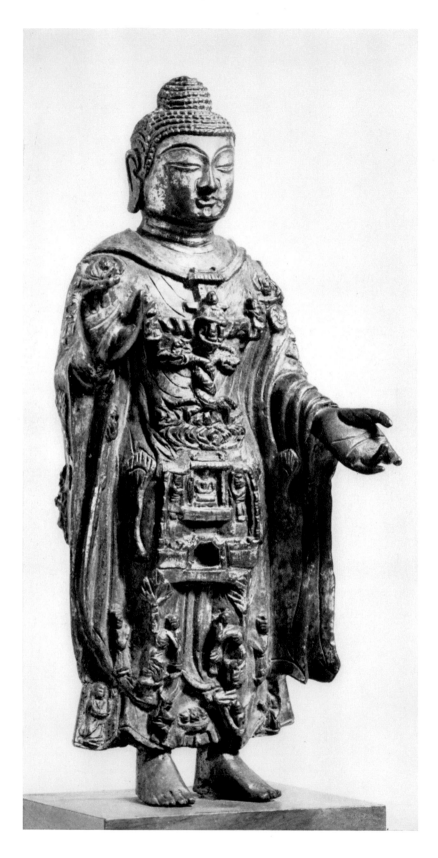

64. Mahā-Vairocana, Cosmic Buddha
China, Sui dynasty, 589–618
Gilt bronze; H. 5½ *in.*

65. Guardian Deity
China; late sixth–early seventh century
Gilt bronze; H. 4½ in.

66. Celestial Dancer
China; T'ang dynasty, eighth century
Gilt bronze; H. 4¾ in.

India: Miniatures

THE original collections assembled by Emile Guimet included a group of Indian miniatures which was not, with a few exceptions, of the highest quality, probably because their documentary aspects took precedence in his choices. The case was not the same at the Louvre, whose collection originated during the Napoleonic era. Even though the collection tended to emphasize Persian miniatures, the Louvre collection was progressively enriched by important bequests of Indian paintings and by numerous acquisitions. The taste, nevertheless, favored the Mughal School, whose Iranian characteristics were preferred by the amateurs of this period. This collection, studied by Ivan Stchoukine and published in Paris in 1929 (*La Peinture indienne à l'époque des Grands Moghols*), was joined in 1945 with the miniatures already in the Museé Guimet. It forms, with the latter, a beautiful collection that has grown through the addition of very fine specimens from the Mughal School as well as from regional schools. These were acquired, for the most part, at public auctions of private collections that had been formed at the beginning of this century.

Andrée Busson

67 TEN BIRDS 3619A
*Mughal School; late sixteenth–
seventeenth century; signed Miskina
Watercolor and gouache on paper;
H. 11 in. (28 cm.), W. 5¾ in. (14.6 cm.)*

This album page bears the notation: "work of Miskina." The name is that of a painter known to have worked at the court of the Emperor Akbar and who is mentioned in *A'in-i Akbari* by Abu'l Fazl Allami, friend and biographer of Akbar. Compositions and illustrations by Miskina, who was perhaps a Moslem of Indian origin, show him to have been a good animal painter. Here ten multicolored birds are assembled, as for a study; some are identifiable but others seem to be imaginary. On the reverse is another study of eight birds. (A.B.)

Published: I. Stchoukine, *La Peinture indienne à l'époque des Grands Moghols* (Paris, 1929), p. 18; A. Busson, *Arts de l'Islam des origines à 1700 dans les collections publiques françaises*, exhibition catalogue, Orangerie des Tuileries (Paris, 1971), no. 353.

68 WHITE BIRDS OF THE MG 9150
MARSHLAND
*Deccani School (Bijapur); ca. 1615
Gouache on paper; H. 4¾ in. (12.4 cm.),
W. 7¼ in. (18.5 cm.)*

This attractive composition is part of the original collection assembled by Emile Guimet. It is obviously only a fragment of a rather large miniature, perhaps a portrait. Two long-legged water birds, wings flapping, are shown at the edge of a pond against a black background dotted with red and blue flowers and aquatic plants. The bird on the left is in the process of swallowing a fish it has just caught. One notes the precision with which the artist has represented the form of these birds while at the same time stylizing their attitudes. Long attributed (like many others) to the Mughal School, this painting shows close analogies with the miniatures produced in Bijapur in the court studio during the reign of Ibrahim 'Adil Shah II (1580–1627), similarities which caused Robert Skelton

to attribute it, with good reason, to this workshop. The lower right area has been repainted. (A.B.)

Published: R. Skelton, "Documents for the Study of Painting at Bijapur in the Late 16th and Early 17th Centuries," *Arts asiatiques*, vol. V, no. 2 (1958), p. 122, fig. 6.

69 SURRENDER OF THE TOWN OF QANDAHAR MA 3318

Mughal School; ca. 1640
Gouache on paper, heightened with
gold; H. 13½ *in.* (34 *cm.*),
W. 9½ *in.* (24.2 *cm.*)

The event depicted here occurred at the beginning of 1638 under the reign of Shāh Jahān (1627–1658), and the importance given to it is easily justified. The town of Qandahar was already a capital when Alexander the Great founded a second Alexandria there in the fourth century B.C. In the eighteenth century, it was the capital of Afghanistan. Throughout history it maintained its key position, which commanded from Afghanistan the passages to India; as a result, it was constantly under fire. At the time of the Mughal conquests, it was a point of contention between the Persian and Indian empires. In 1595, its Persian governor surrendered it to a lieutenant of the Mughal emperor Akbar. But in 1622 Akbar's son, the Emperor Jahāngīr, lost it despite a defense. Jahāngīr ordered his son, Shāh Jahān, to retake Qandahar, but the latter was unsuccessful until, more than ten years later, the Persian governor deserted. This traitor to his master, fearing for his life, opened the gates to the representative of the Mughal emperor and gave him the keys. Not a very glorious surrender in truth, but one which must have seemed important in the eyes of contemporaries. One might add that the province of Qandahar and its capital remained in the hands of Shāh Jahān only until 1649, when the Persians took it again by force—and it was lost forever to the Indian empire.

The miniature illustrating this historic event was probably part of the *Shāh Jahān-nameh*. Its composition and execution are of very high quality. At the top of the page is a city surrounded by ramparts, seen as if from above, and in the center the Persian dignitaries surrender and turn over the keys of the city to the representative of the Mughal emperor. Calligraphy appears on the reverse. (A.B.)

Acquired in 1970; formerly J. Pozzi Collection.

Published: E. Blochet, *Catalogue des manuscrits persans de la Bibliothèque nationale* (Paris, 1905), pl. XXXIX, no. 21; J. Soustiel, *Catalogue de la vente Pozzi* (1970), no. 76; Busson, *Arts de l'Islam*, no. 358.

70 GAZELLE HUNT AT NIGHT MA 3319

Mughal School, Oudh; eighteenth
century; signed Manuhar Das
Gouache on paper; H. 15½ *in.* (39 *cm.*)
W. 10¾ *in.* (27.4 *cm.*)

The scene is a rocky landscape, with trees and a pond where herons wade. The narrative is divided into four distinct episodes. A young couple is at right center; the man, with a quiver in his belt, shoots an arrow into a herd of seven gazelles while the woman lights the scene with a torch. To the left, another couple lights a wood fire. Below, at the left, a man carries a dead gazelle on his shoulders. To the right, nine people (six women and three men) are grouped in front of two grass huts where, in the foreground, the gazelle (black buck) is prepared for the meal.

The people are clothed in skirts made of leaves and some wear low shoes and headdresses. This was the usual costume of certain tribes, notably the Bhils—at least that is how the Mughal painters depicted them. The chiaroscuro effects sought by the painter are found frequently in works of the Mughal School, and this is attributed to the influence of Western painting.

A similar painting, perhaps by the same artist, is preserved in the Bodleian Library, Oxford. (A.B.)

Acquired in 1970; formerly F. Prévost and J. Pozzi collections.

Published: J. Pozzi, *Miniatures indiennes du temps des Grand Moghols* (Paris, 1950), pl. VI; Soustiel, *Catalogue de la vente Pozzi*, no. 78.

71 PROMENADE AA 6031
Pahari School (probably Chamba);
late eighteenth century
Gouache on paper; H. 10¾ *in.* (27.3 *cm.*),
W. 8 *in.* (20.4 *cm.*)

An important Punjabi nobleman, with a long black beard, walks with his favorite beneath a canopy on the white marble terrace of his palace. Four servants accompany them, two holding hookahs (waterpipes) for the nobleman and his lady while the others carry a fly-whisk and the prince's sword. In the foreground, two ducks follow at the edge of a pool with a fountain. In the background, beyond a white marble portico, are typical Mughal gardens (inspired by the Persian) and a pavilion where a large cushion invites rest. Peacocks and servants stroll in the garden.

The painting is of fine quality. William G. Archer (*Indian Painting in the Punjab Hills*, London, 1952) believes that he has recognized in it the portrait of Rāj Singh of Chamba, and relates it to the Guler school (pl. 34 and pp. 43–44). (A.B.)

Gift of Soldi Colbert, 1905.

Published: I. Stchoukine, *Miniatures indiennes au Musée du Louvre* (Paris, 1929), pl. xx, no. 119.

67. Ten Birds
India; late sixteenth–seventeenth century
Watercolor and gouache on paper; H. II *in.*

68. White Birds of the Marshland. *India; ca.* 1615. *Gouache on paper;* H. 4¾ *in.*

69. Surrender of the Town of Qandahar. *India; ca. 1640. Gouache on paper, heightened with gold;* H. 13½ *in.*

70. Gazelle Hunt at Night. *India; eighteenth century. Gouache on paper;* H. 15½ *in.*

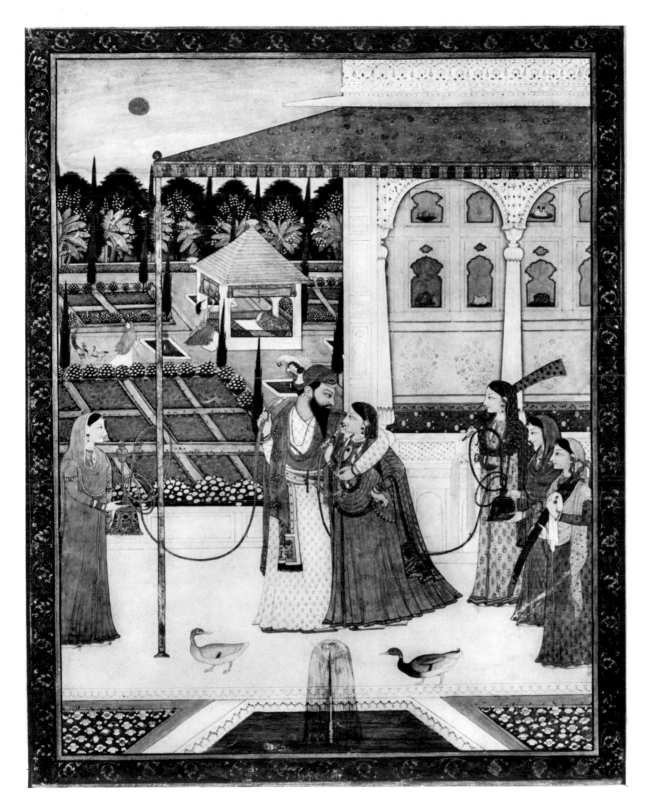

71. Promenade. *India; late eighteenth century. Gouache on paper;* H. 10¾ *in.*

PHOTOGRAPH CREDITS

Musée Guimet: Nos. 1, 5–7, 11, 18, 20, 27, 32, 34, 44, 58.
Jacqueline Hyde: Nos. 2, 4, 9 (back), 10, 11 (detail), 15–17, 22–26, 28, 33 (detail), 35–39, 41, 43, 44 (details), 46, 48–50, 52–57, 59–71.
Kodansha Publishers, Tokyo: Nos. 3, 8, 9 (front), 12–14, 19, 21, 29–31, 33, 40, 42, 45, 47, 51.

Designed by Bert Clarke
Composition by A. Colish, Inc., Mount Vernon, N.Y.
Production supervised by John Weatherhill, Inc., New York and Tokyo
Printed in gravure and lithography by Nissha Printing Co. Ltd., Kyoto

Translations of the catalogue entries were provided by the French Consulate, New York; Herma Briffault translated the Introduction.